Rocky Mountain National Park

A Year in Pictures

by David Dahms

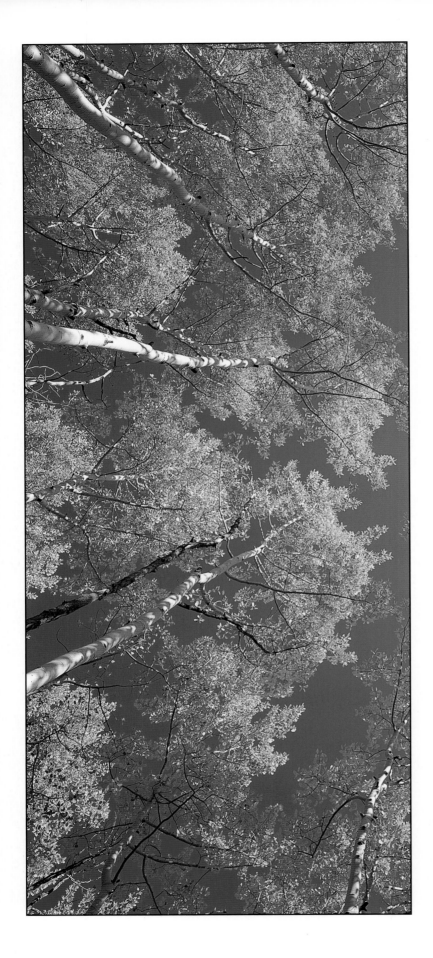

published by
Paragon Press
991 Ridge West Drive
Windsor, CO 80550

www.paragon-press.com

Printed in South Korea

ISBN 0-9646359-3-3 softcover
0-9646359-4-1 hardcover

Front cover:
The Longs Peak Diamond shines at sunrise

Title page:
A winter sunset in Moraine Park

Left:
Aspen trunks reach for the sky

Back cover:
Hallett Peak over Dream Lake
Aspen in Endovalley
Ypsilon Mountain
Elk calf

David Dahms is a professional nature and wildlife photographer specializing in the Rocky Mountain National Park region. His work has appeared in regional and national calendars and magazines. Other books by this author include *Rocky Mountain Wildlife* and *Rocky Mountain Wildflowers Pocket Guide*.

The photographs in this book were taken with a Canon A-1 35mm camera system or a Mamiya 7 medium format system. However, equipment details are much less important than simple patience and persistence. Even if the weather or wildlife does not cooperate, any day in the park is a good day.

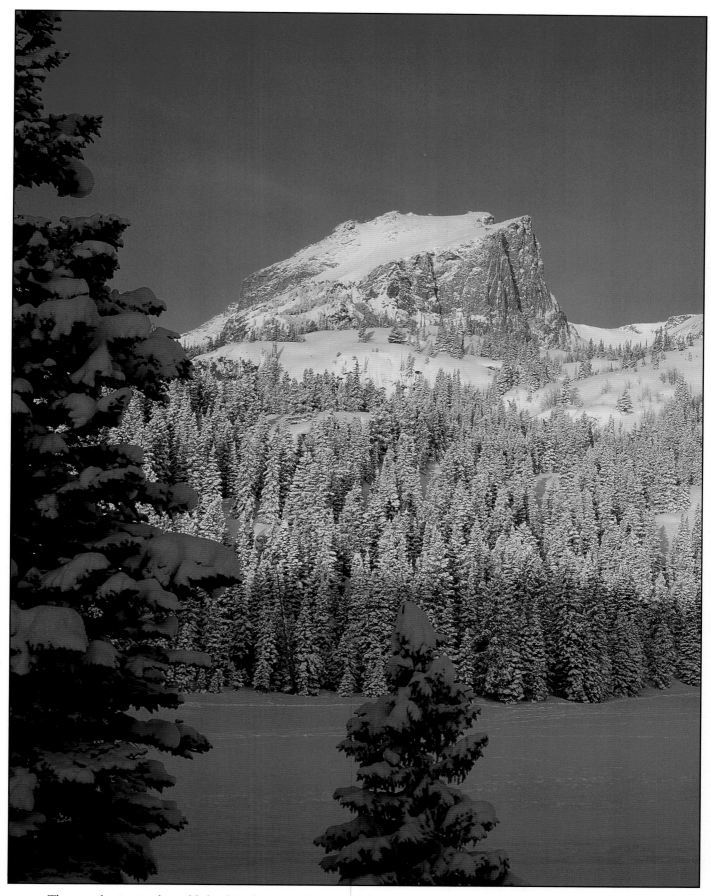

The year begins in the cold depths of winter, the season of quiet solitude and stark beauty in the park. Familiar landmarks such as Hallett Peak and Bear Lake look much different when coated by a pristine mantle of snow from a passing storm.

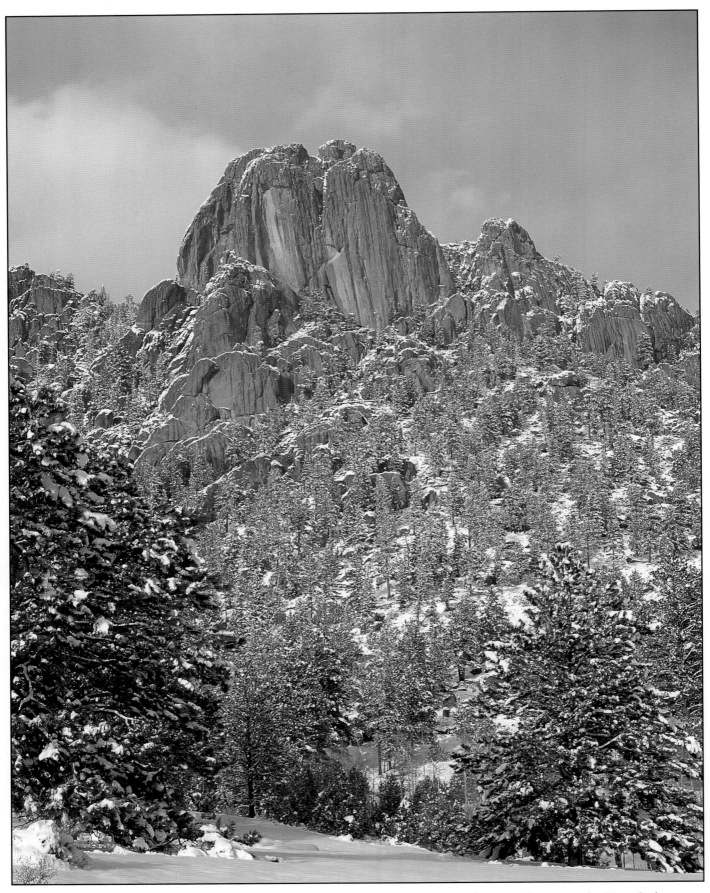

The Lumpy Ridge area north of Estes Park is home to this prominent granite formation known as the Twin Owls. Technical mountain climbers test their skills on the vertical rock faces in this area, although some sections are closed to visitors in the spring to protect raptor nests high on the cliffs.

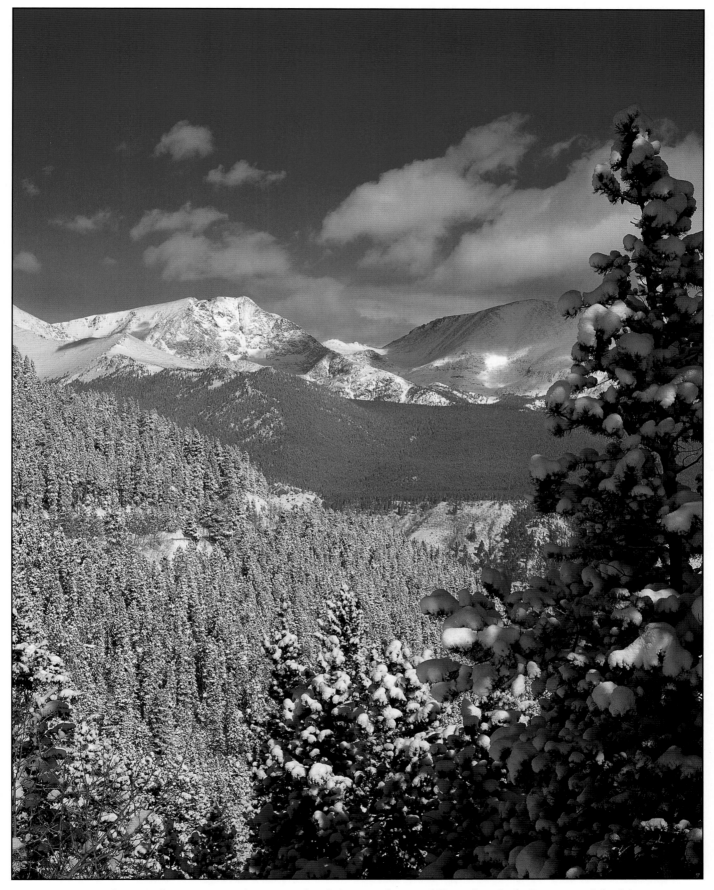

At 13,514 feet, Ypsilon Mountain dominates the skyline northwest of Horseshoe Park. It is part of the Mummy Range, a group of mountains in the northern region of the park

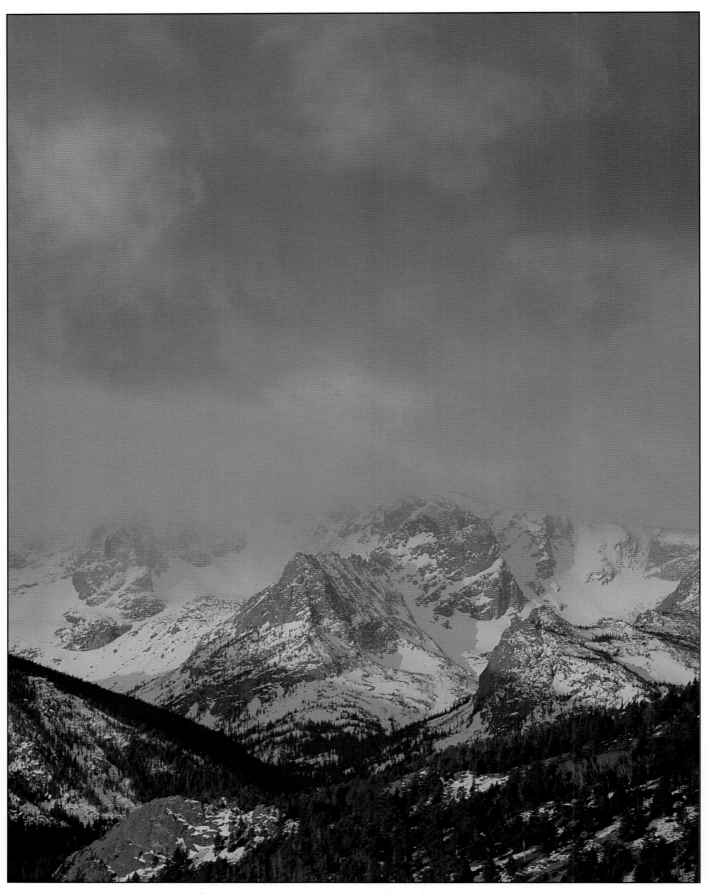

A clearing winter storm swirls among the peaks of Odessa Gorge.

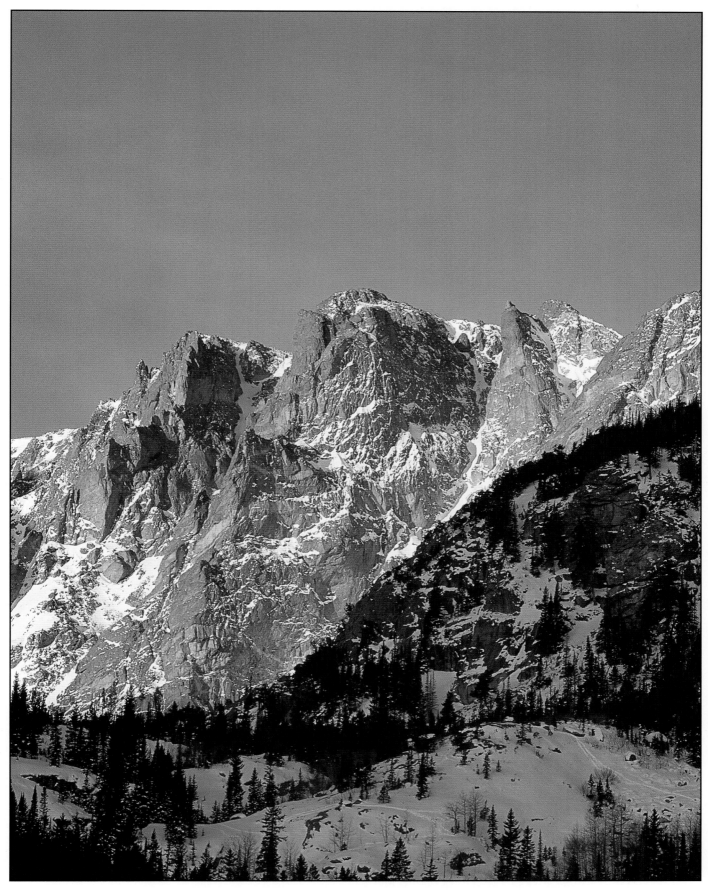

Although it may be flat on top, Flattop Mountain has jagged spires on its southeastern flank.

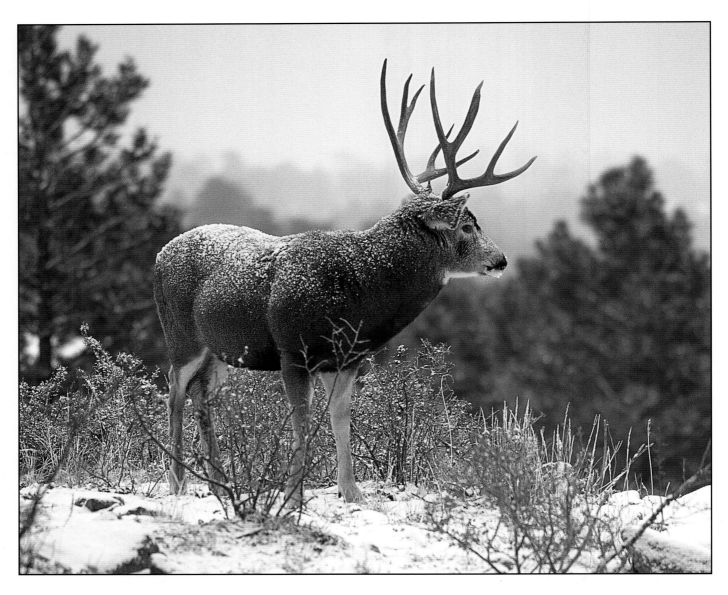

Winter is a test of survival for the wildlife. Although animals like this mule deer buck constantly forage for any remaining vegetation, they rely on reserves of fat accumulated during the past summer. Winter is particularly trying for dominant male animals since they deplete much of their reserves during the autumn mating season.

The ubiquitous coyote is a common predator and scavenger throughout the park and much of the nation. Coyotes are very adaptable and have a varied opportunistic diet, including plants, birds, carrion, and rodents. Several coyotes may team up to attack larger prey, like a deer or elk. A coyote can hear a mouse scurrying under the snow and will pounce into a snowbank to retrieve it. At night, their haunting howls echo through the mountains.

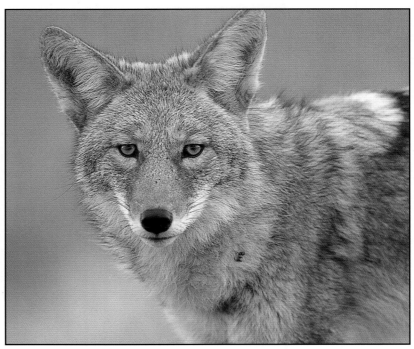

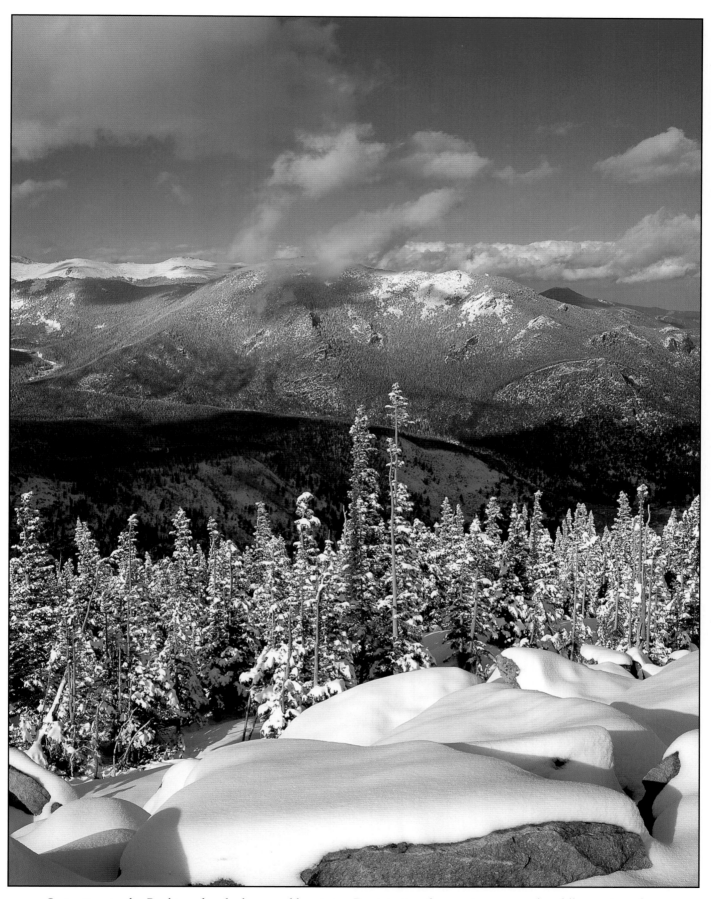

Springtime in the Rockies often looks more like winter. Precipitation from spring storms that falls as rain at lower elevations will be snow in these mountains. These trees near treeline as well as distant Bighorn Mountain are coated with snow from a mid-May storm.

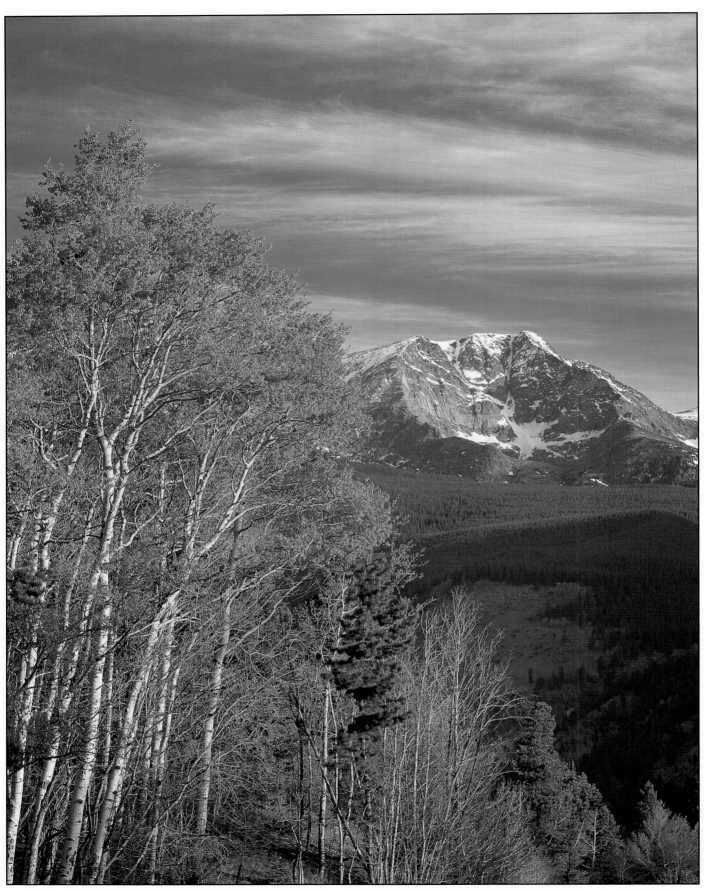

New aspen leaves burst forth in a refreshing splash of color in the spring. The new leaves are a light lime-green color at first, before changing to their darker summertime hue.

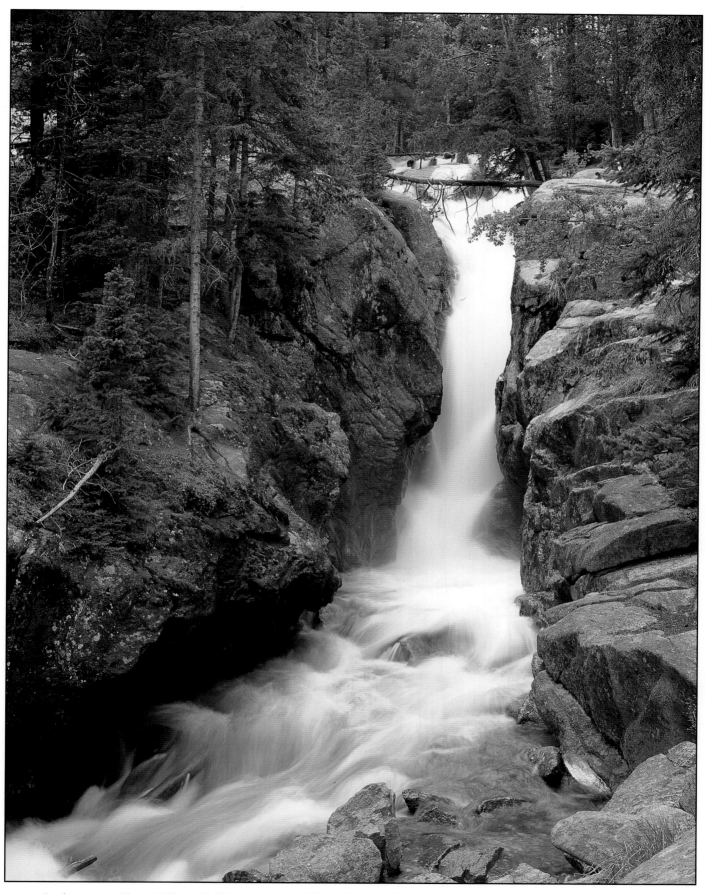

In the spring, Chasm Falls on Fall River surges to life with runoff from melting snow. Chasm Falls is about a mile up Fall River Road and can be reached by an easy springtime hike or a summer drive.

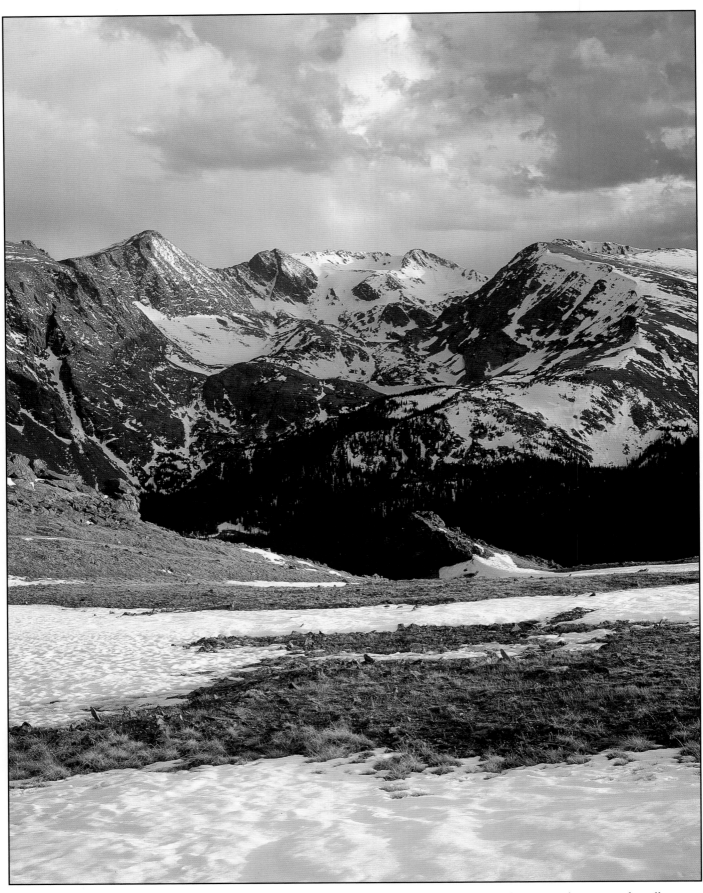

The summits of Mount Julian, Cracktop Mountain, Chief Cheley Peak, and Mount Ida surround a group of small alpine lakes, often called the Gorge Lakes, which remain frozen and hidden under snow well into July.

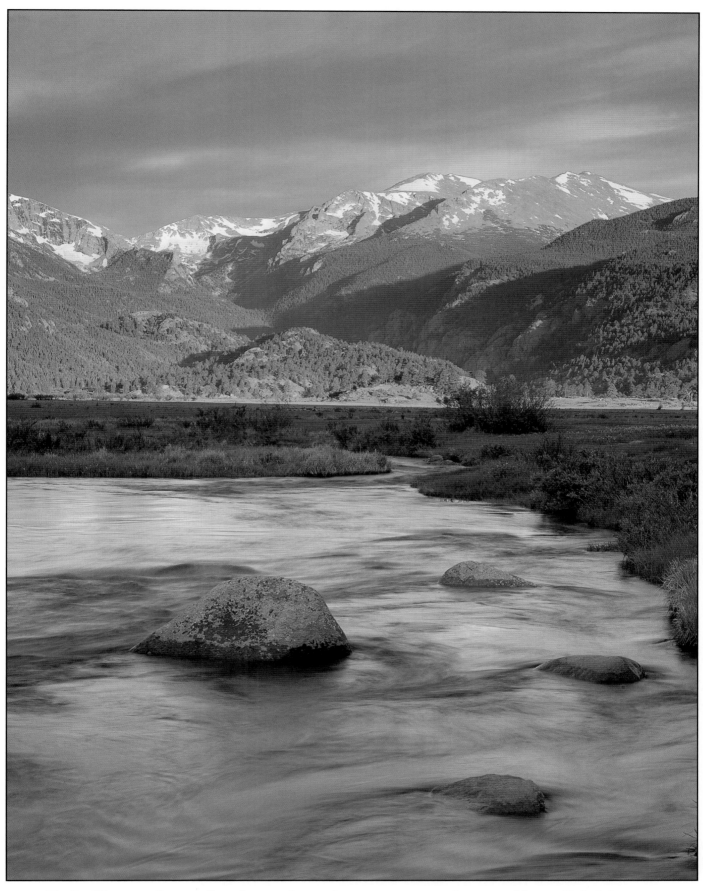

The Big Thompson River swells with water from melting snow as it meanders across Moraine Park. It begins in Forest Canyon near the Alpine Visitor Center.

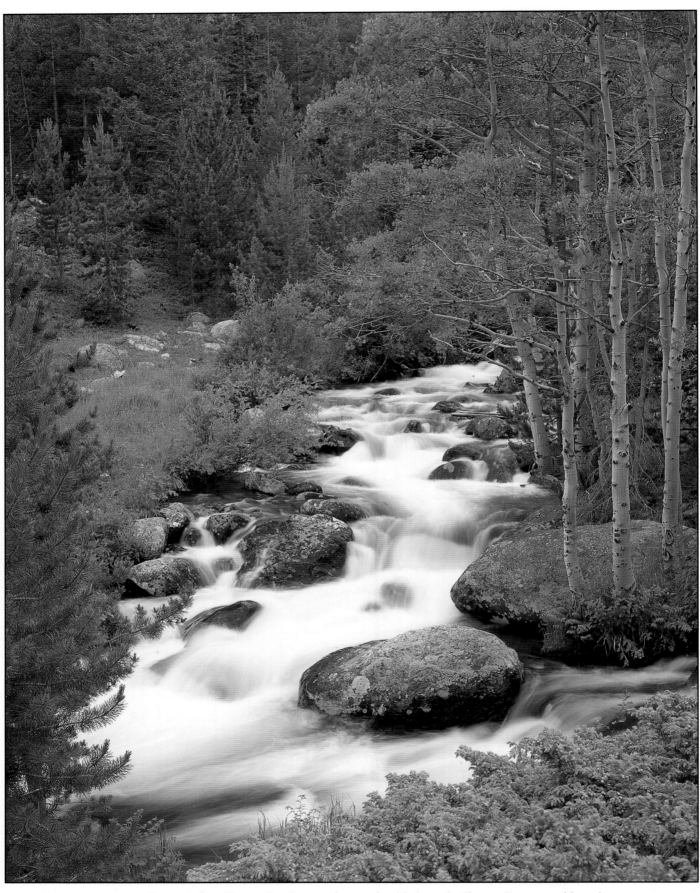

From its source at Frozen Lake, Glacier Creek runs clear and cold through Glacier Gorge, tumbling down many lovely cascades along the way.

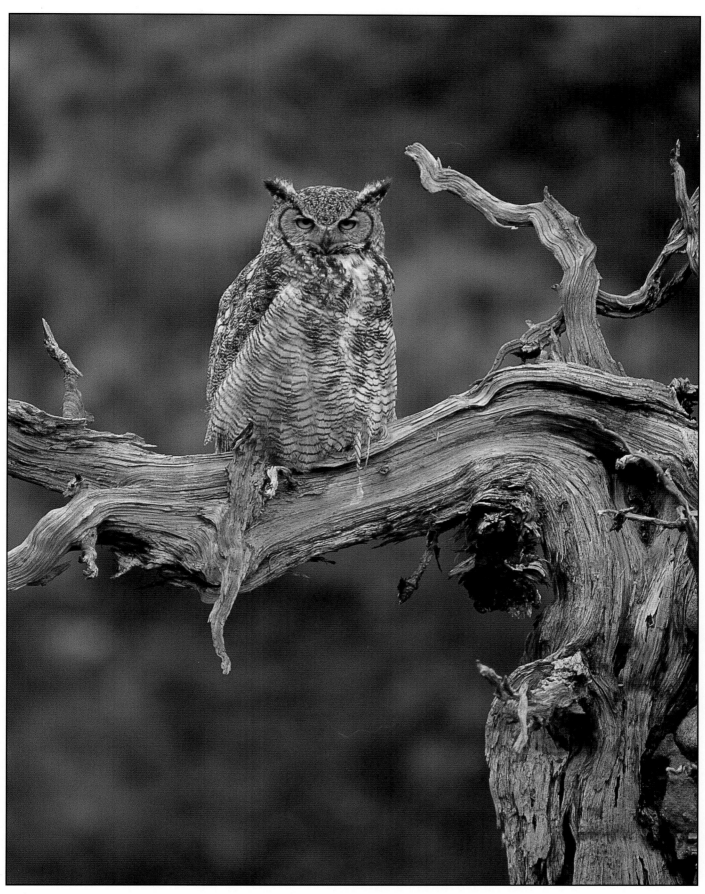

A great horned owl rests on the roots of a fallen ponderosa pine tree in Moraine Park before beginning its nocturnal hunting activities. Owls have extremely sensitive large eyes that are fixed in their sockets, so an owl must move its head to shift its gaze.

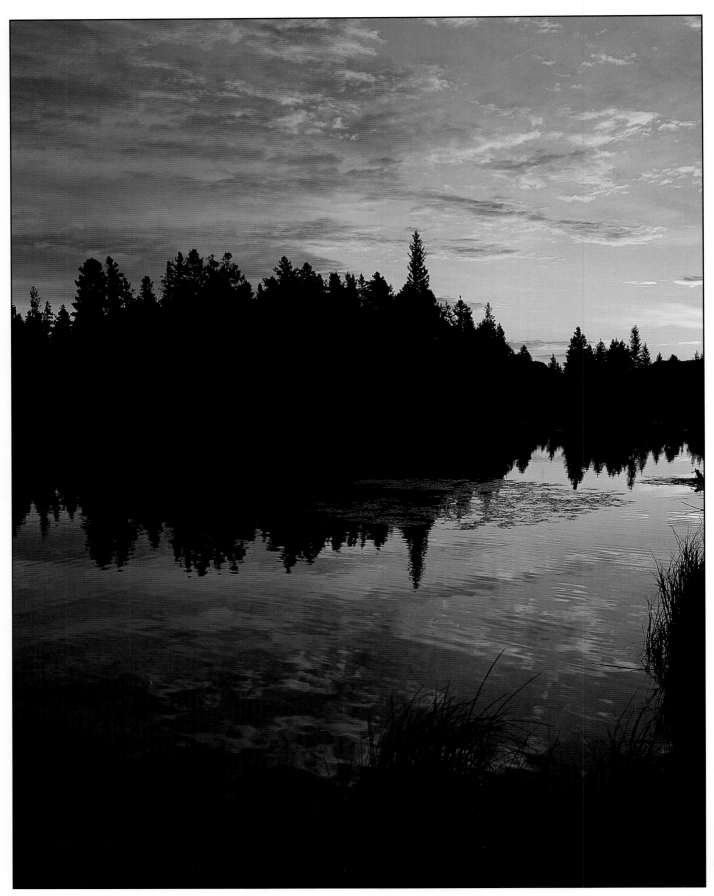

The colorful morning sky reflects in Sprague Lake. In the early 1900's, Abner Sprague built this lake from a beaver pond as a fishing spot for his nearby inn. He came to Colorado in 1864 at age 15, and during his lifetime he was a guide, explorer, surveyor, cartographer, innkeeper, and a prominent figure in the history and development of the park.

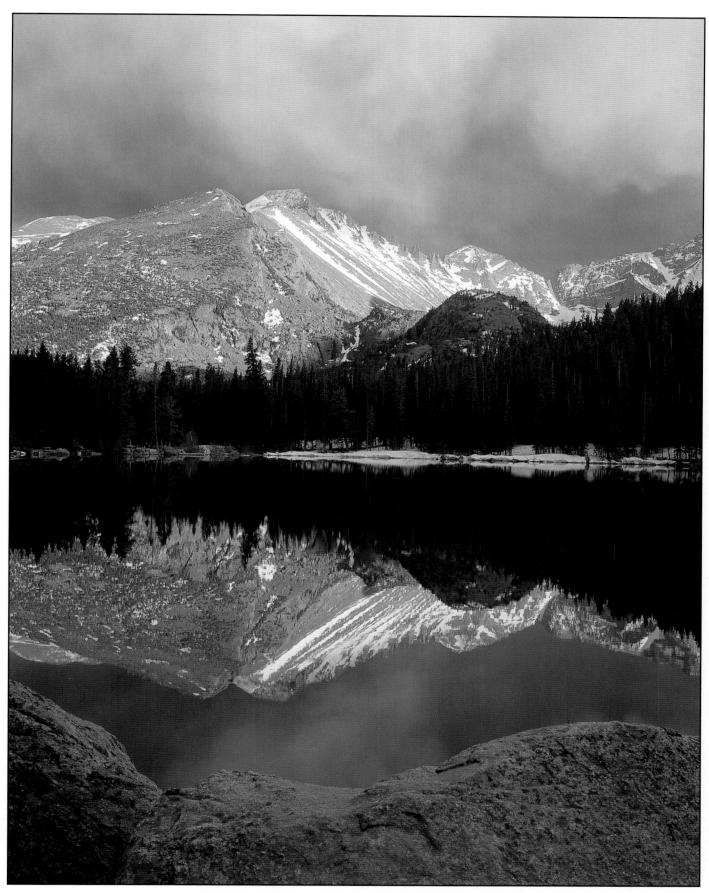

Foreground boulders and placid waters mirror the skyline over Bear Lake as an evening rainstorm brews overhead. The massive summit of Longs Peak dominates the view, accompanied by the jagged spires of the Keyboard of the Winds and Pagoda Mountain.

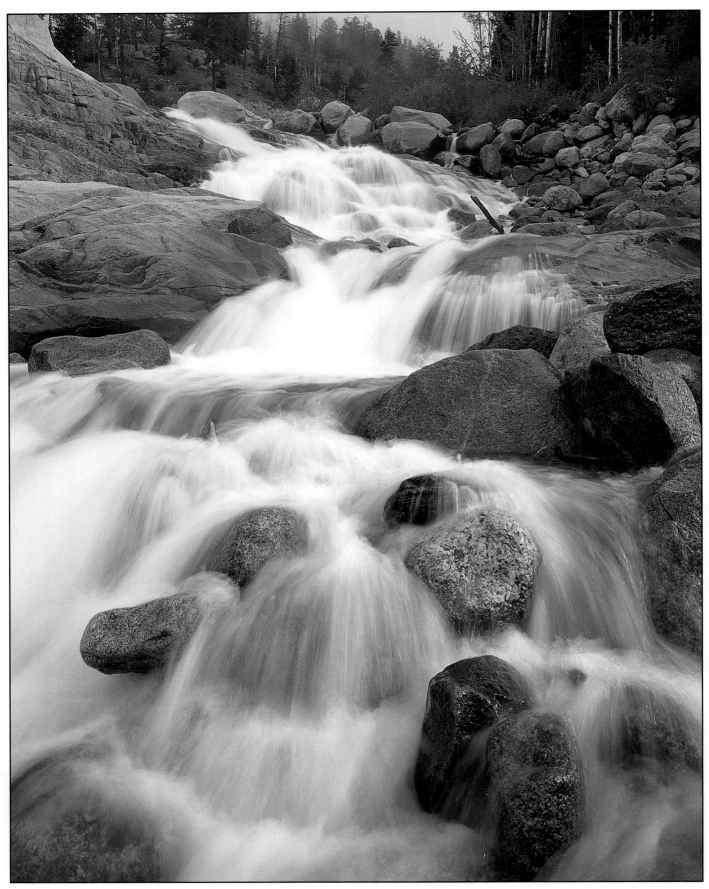

Roaring River cascades over the rounded rocks of Horseshoe Falls. This waterfall is above the Alluvial Fan which was formed on July 15, 1982, when the Lawn Lake dam failed and sent over 200 million gallons of water surging downhill. The resulting torrent buried the road under 40 feet of rubble and flooded downtown Estes Park.

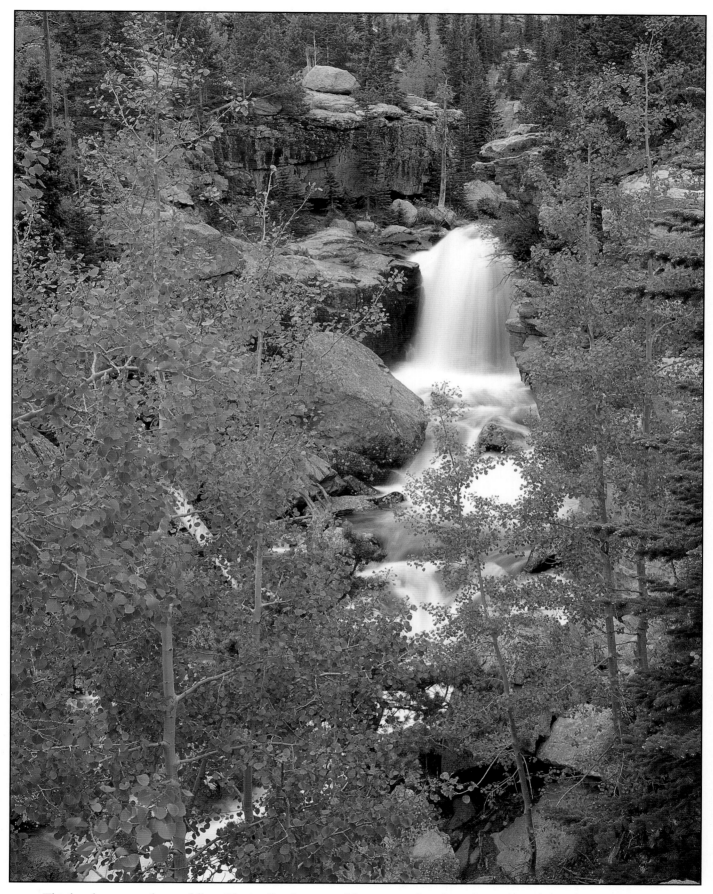

This lovely unnamed waterfall on Glacier Creek is one of the many sights along the trail to The Loch and Mills Lake.

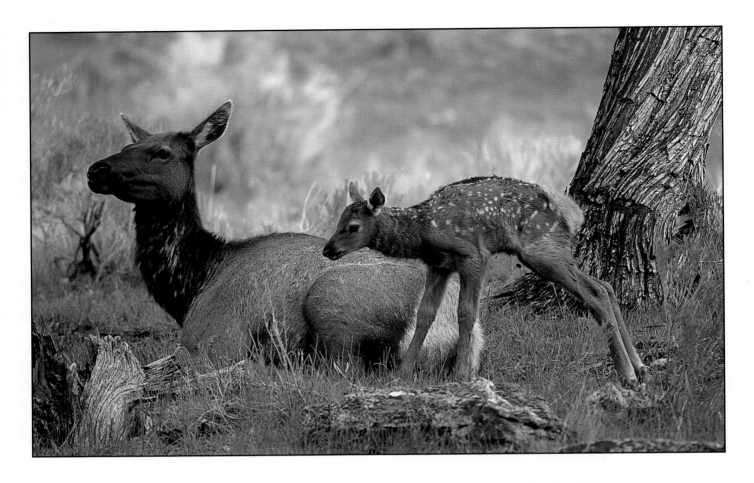

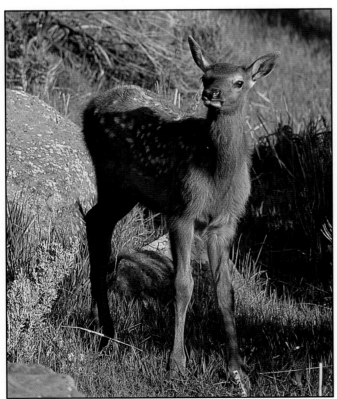

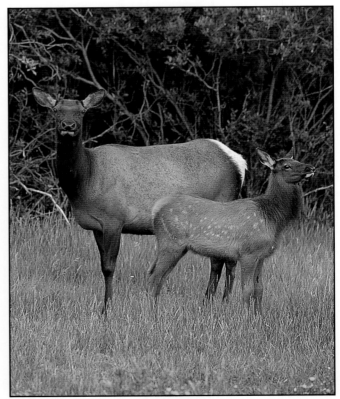

Elk calves are born in early June. This newborn calf (top) struggles to its feet for the first time. Calves rest in secluded areas for the first few weeks, concealed by their spotted coats. Their mothers graze at a watchful distance and return periodically to nurse. The calves grow quickly and soon join the herd of cows. Cow elk may seem docile but can become very aggressive when defending their calves.

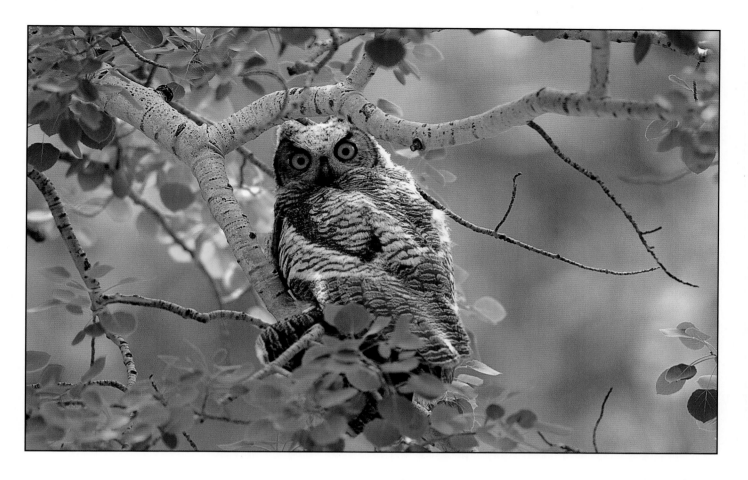

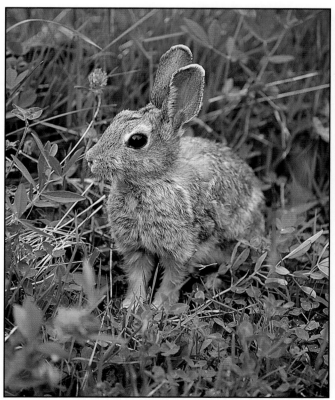

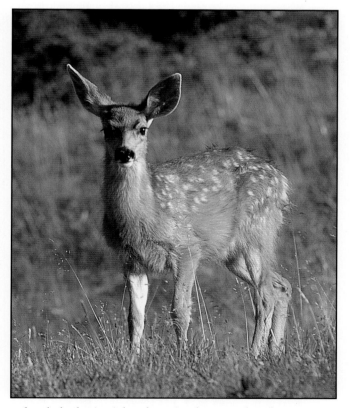

It's always a treat to see baby animals in the park. Great horned owl chicks (top) hatch in April, covered in dense coats of fuzzy white down. Over the next two months, they will develop feathers before leaving the nest. Mountain cottontails (bottom left) are the most common rabbit in the Rocky Mountains. Up to five litters of babies are born each year, blind and naked in a secluded fur-lined nest on the ground. Mule deer fawns (bottom right) are born in the late spring, covered with white spots for camouflage.

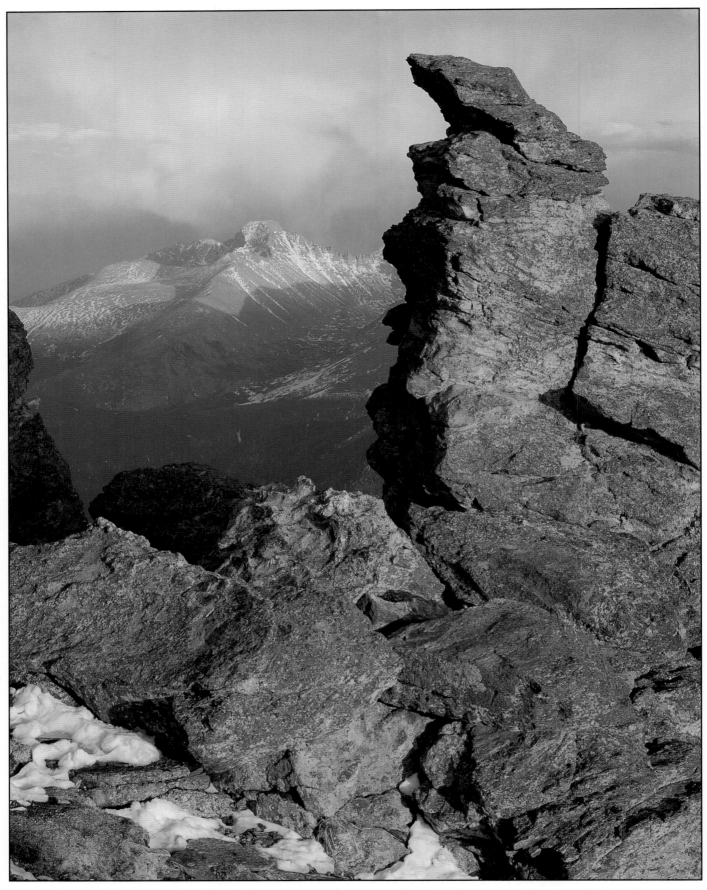

The jagged formations of Rock Cut frame Longs Peak at sunset. Longs Peak was named for Major Stephen Long who led an expedition through the area in 1820, although he was never closer than 40 miles to the peak which now bears his name.

x

22

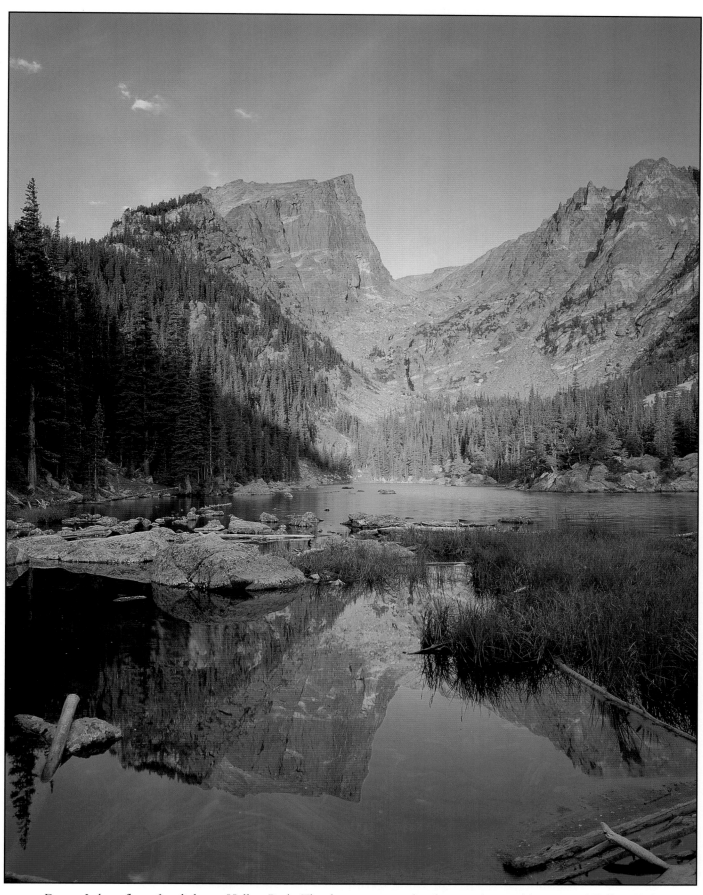

Dream Lake reflects first light on Hallett Peak. The distinctive angular shape and central location of Hallett Peak make it a prominent landmark in the park.

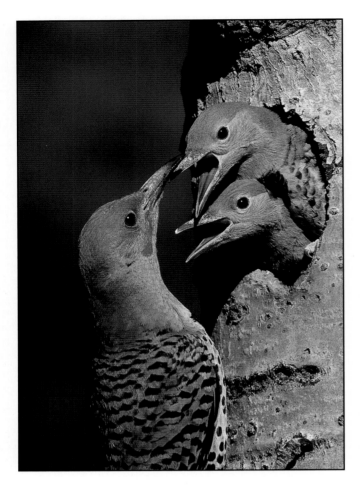

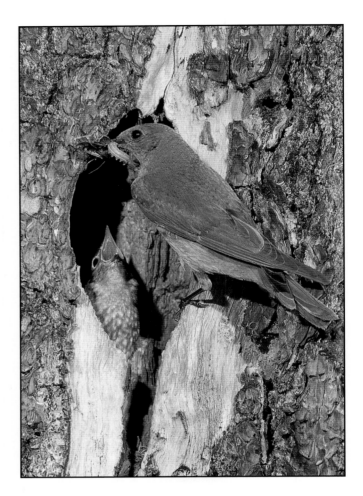

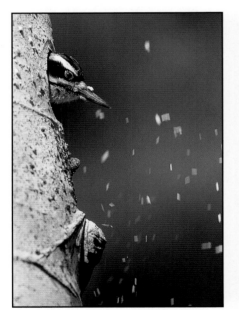

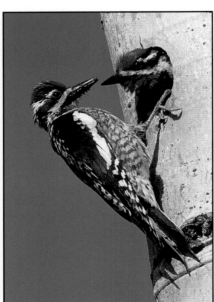

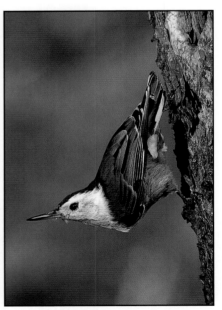

Most birds begin their nesting activities in early June. Birds in the woodpecker family carve out hollow cavities in trees for their nests, using their pointed beaks as chisels. This hairy woodpecker (bottom left) is clearing wood chips from its new nest hole in an aspen tree. Many other birds rely on cavities left by woodpeckers to build their nests, including the white-breasted nuthatch (bottom right) and the mountain bluebird (top right). The eggs are incubated by one or both parents for about two weeks. After the chicks hatch, both adults constantly search for insects to feed their hungry brood. A red-naped sapsucker (bottom center) arrives at its nest with a beak full of fresh ants, while its mate heads out for more. The northern flicker (top left) also collects ants for his chicks, and feeds them by regurgitating into their gaping mouths. The mountain bluebird brings whole insects to its insatiable chicks. The chicks grow rapidly and get quite large before fledging.

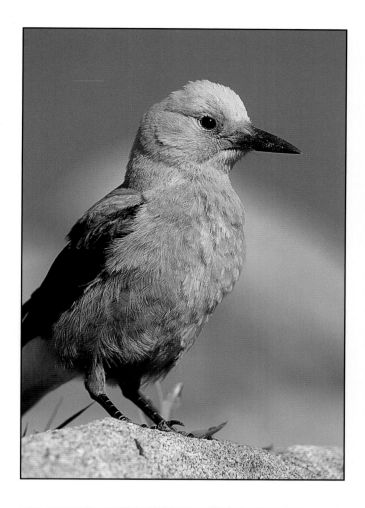

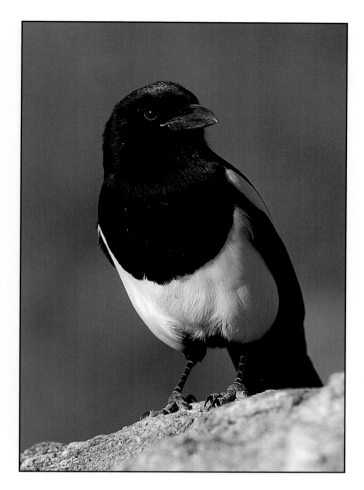

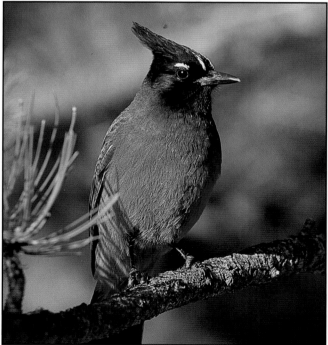

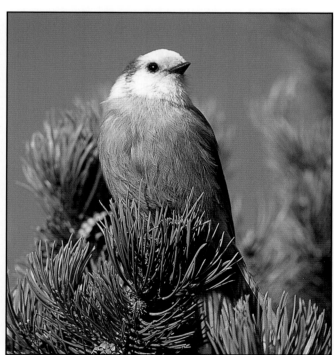

These four birds of the Corvid (crow) family may be seen in the park year round, especially at overlooks and picnic areas. The Clark's nutcracker (top left) primarily eats seeds of the limber pine, caching some underground which helps propagate the trees. Black-billed magpies (top right) are large scavenger birds, conspicuous and gregarious, with white and iridescent black feathers and very long tails. The Steller's jay (bottom left) is deep blue with a black crested head and quite vocal. The gray jay (bottom right) is much quieter and has fluffy gray plumage.

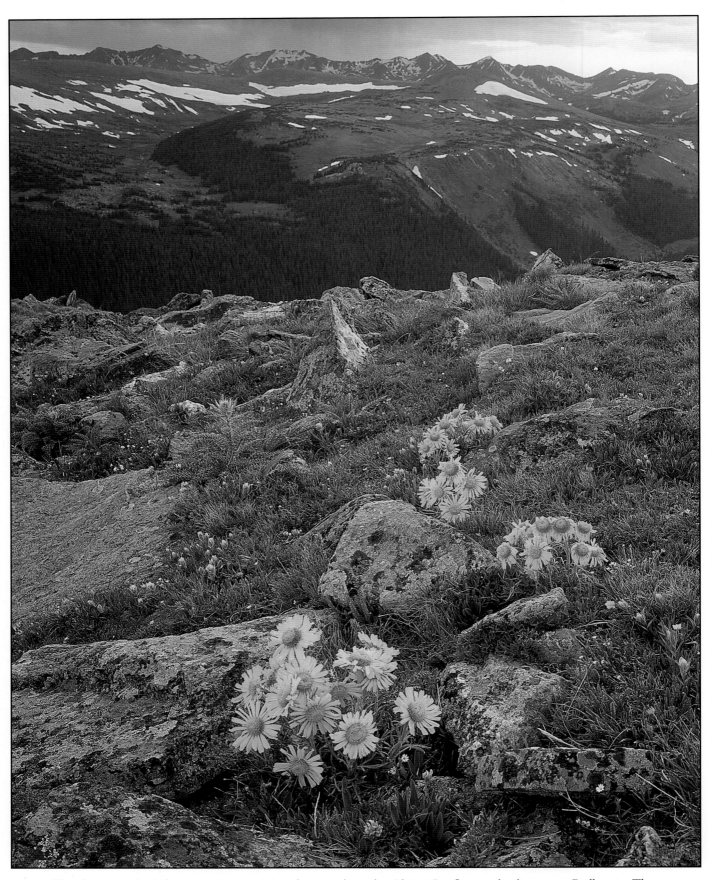

The alpine tundra is home to many unique plants such as the Alpine Sunflower, also known as Rydbergia. These plants grow for several years before blooming, then their yellow flowers face east, away from the prevailing wind. Alpine tundra may seem barren but is actually a fragile ecosystem with many unusual plants similar to those found north of the Arctic Circle, which are specially adapted to the extremely harsh weather conditions.

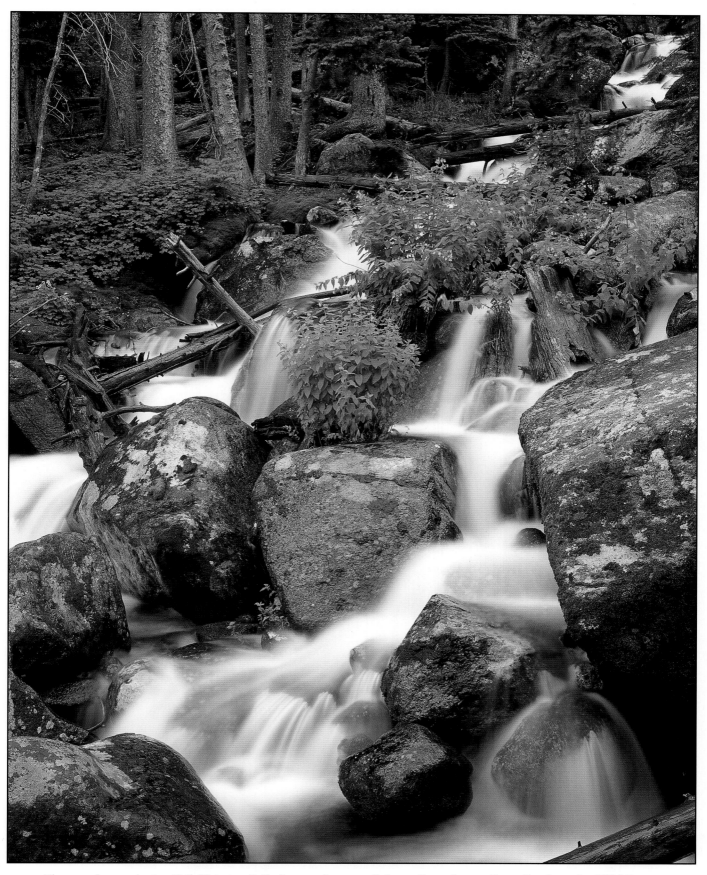

Clumps of water-loving Tall Chiming Bells flowers decorate Calypso Cascades on Cony Creek in the Wild Basin area of the park. It was named for the Calypso Orchid, a rare and unusual small pink flower that sometimes grows in the damp forest area nearby.

Globeflower

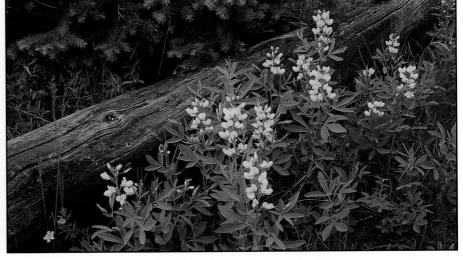

Golden Banner

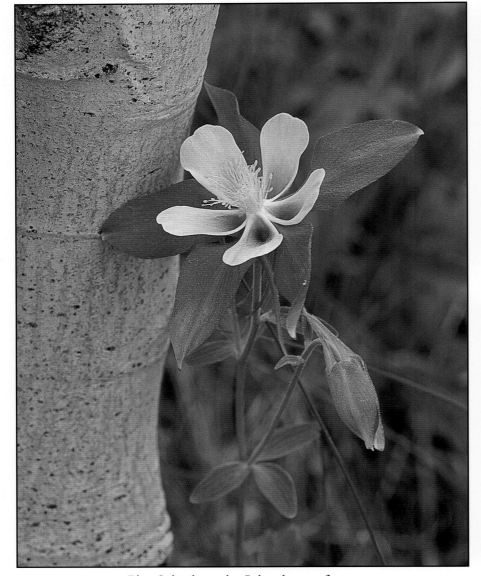

Blue Columbine, the Colorado state flower

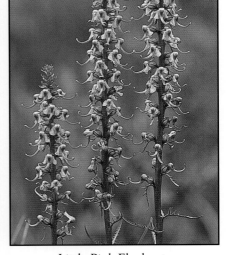

Little Pink Elephants

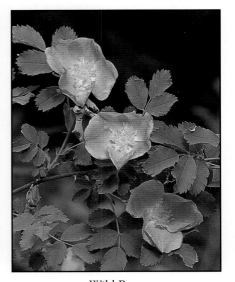

Wild Rose

Pasqueflower

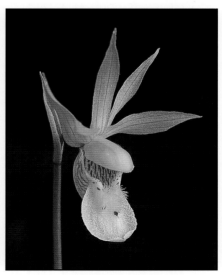

Wild Iris

Black-eyed Susan

Sego Lily

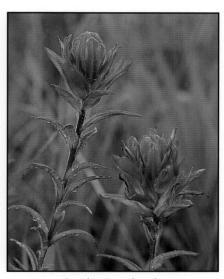

Scarlet Paintbrush

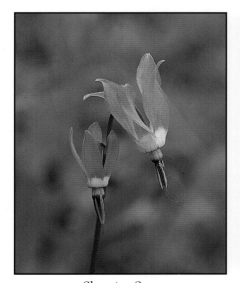

Shooting Star

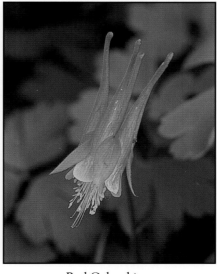

Red Columbine

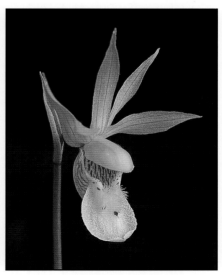

Calypso Orchid

29

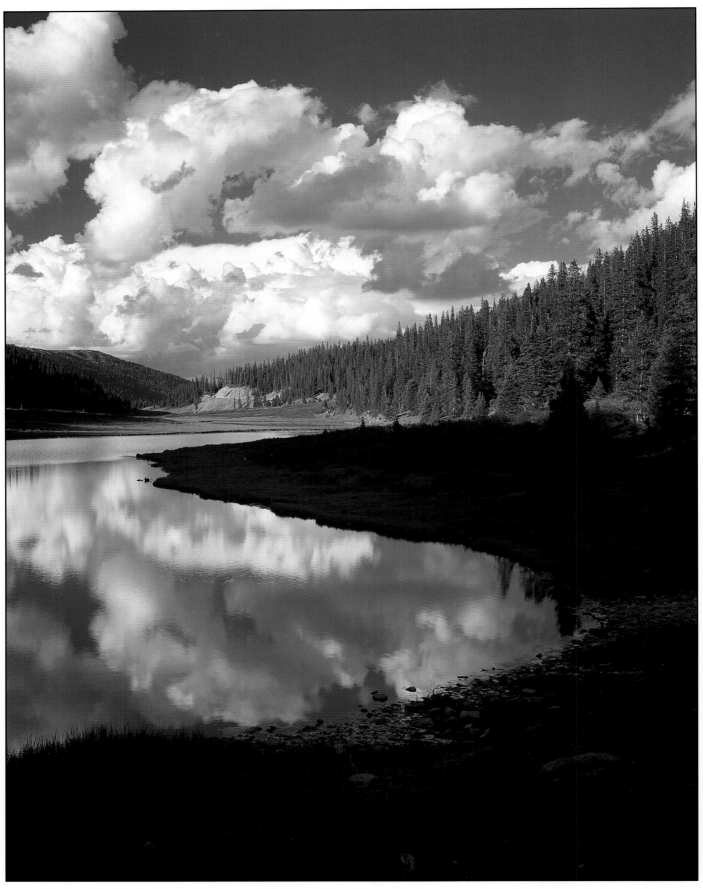

Poudre Lake lies beside the Continental Divide at Milner Pass and is the source of the Cache la Poudre River. The Continental Divide is an imaginary line across high ridgelines which separates streams that drain to the Atlantic and Pacific Oceans.

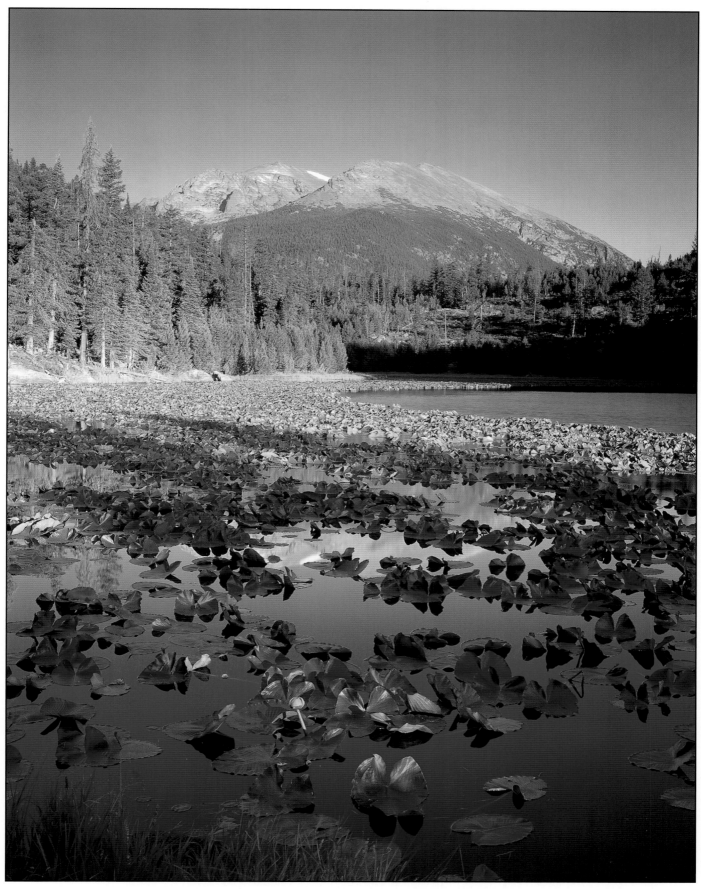

Yellow pond lilies dot the tranquil surface of Cub Lake with Stones Peak in the distance. The trail to Cub Lake winds around Moraine Park, through a prime birdwatching area.

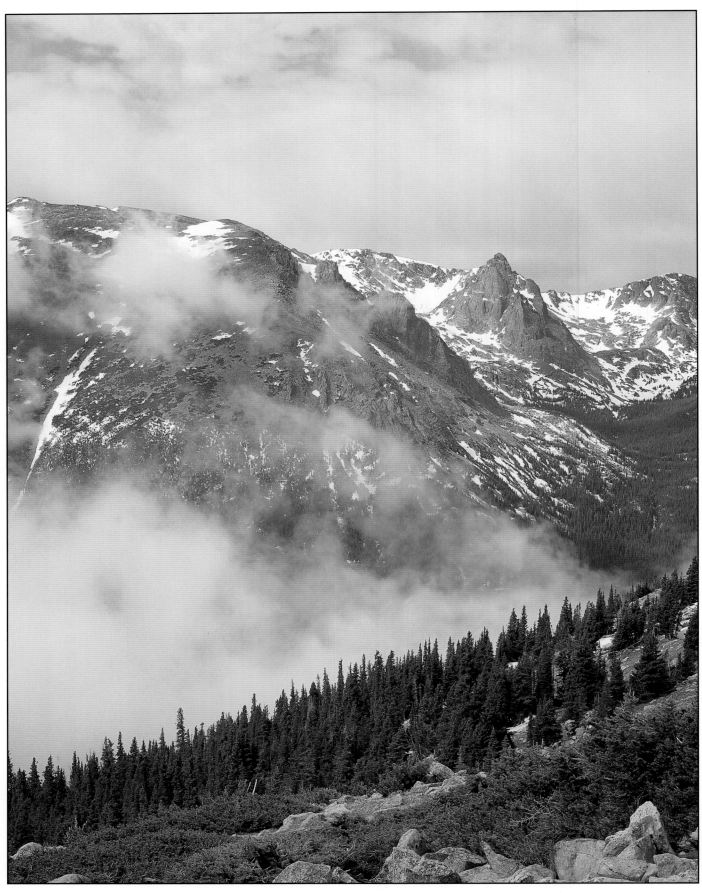

Clouds and fog swirl around Stones Peak and Hayden Spire. An easterly wind may blow humid air upslope from the plains, where it cools and condenses to form clouds, fog, or storms.

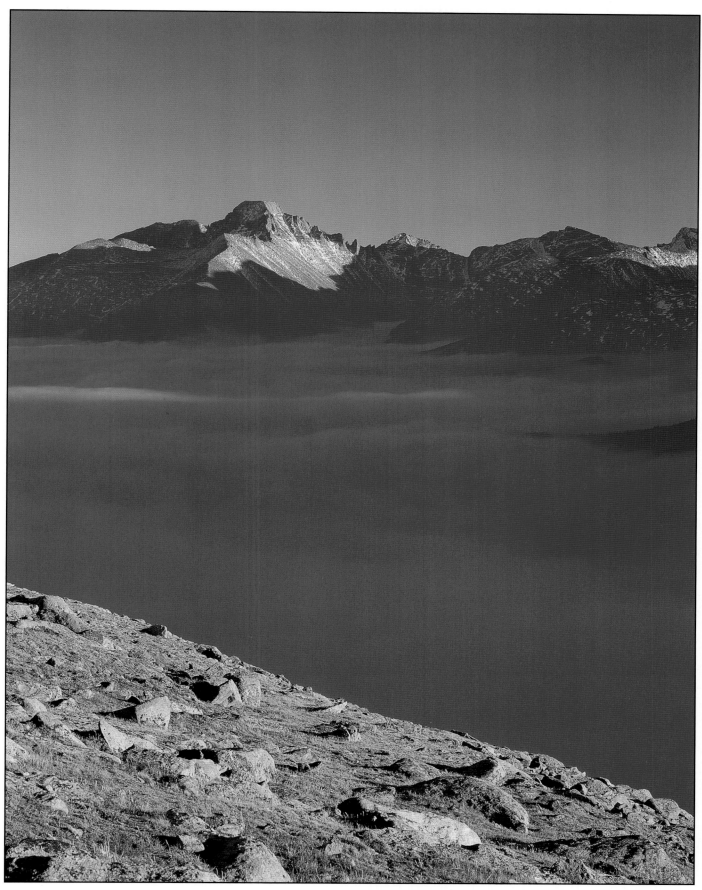

A low-hanging cloud bank fills Forest Canyon while Longs Peak shines with warm evening light. Rising to 14,259 feet, Longs Peak is the highest point in the park.

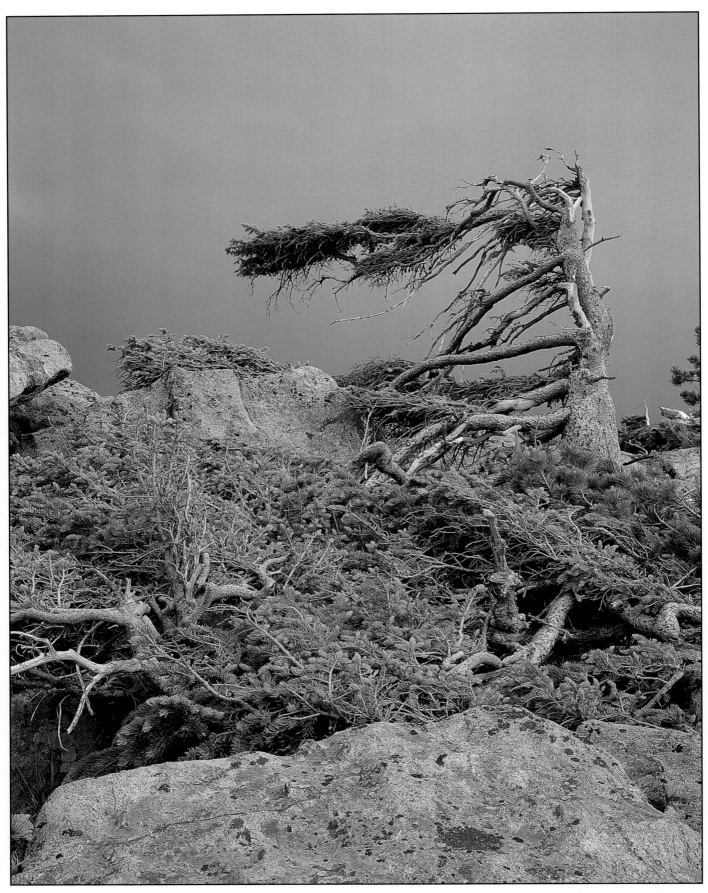

These gnarled trees barely cling to life in the hostile environment near treeline. Scoured by wind-driven ice crystals in raging winter storms, these stunted trees seek shelter behind rocks and only grow branches on the downwind side of their own trunks.

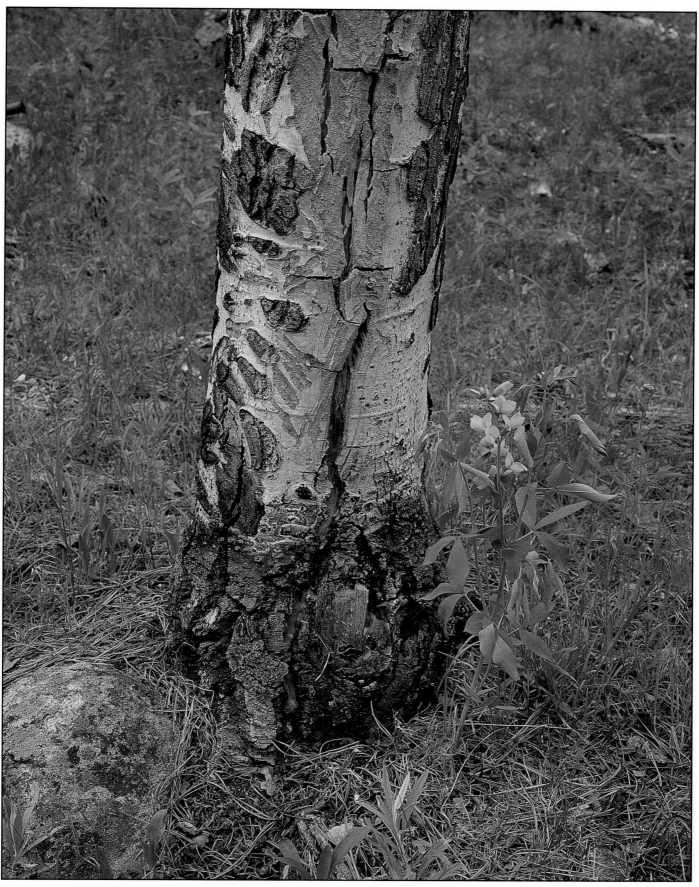

The irregular black marks that cover most aspen trunks in the park are caused by elk. They nibble at the aspen bark, leaving fresh brown marks that turn black when affected by a fungus.

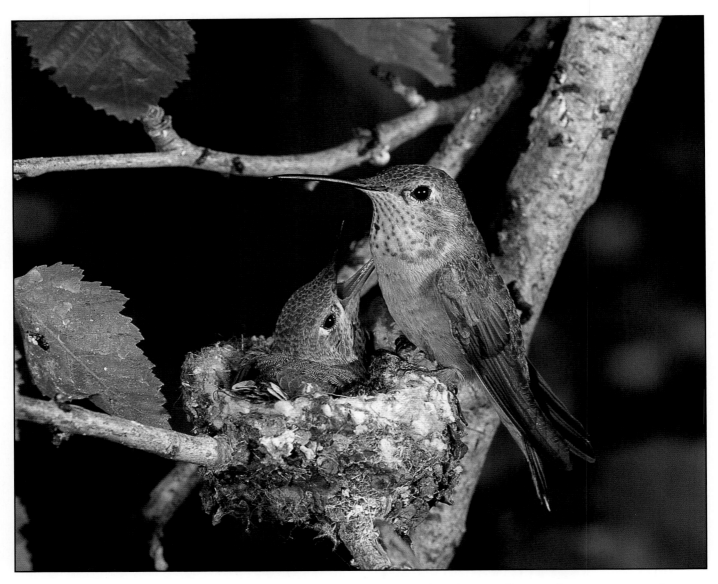

Broad-tailed hummingbirds are commonly seen in the park, skipping from flower to flower and sipping nectar with their long beaks. They are metallic green and tan, and males have an iridescent red neck patch. Their rapid wingbeat produces a buzzing sound which rises in pitch during courtship displays in early July. The female hummingbird builds her tiny nest of lichen and spider web, lays and incubates two eggs, and feeds her chicks, all with no help from the male. An adult hummingbird is about four inches long and weighs only four grams, about the same as a single penny.

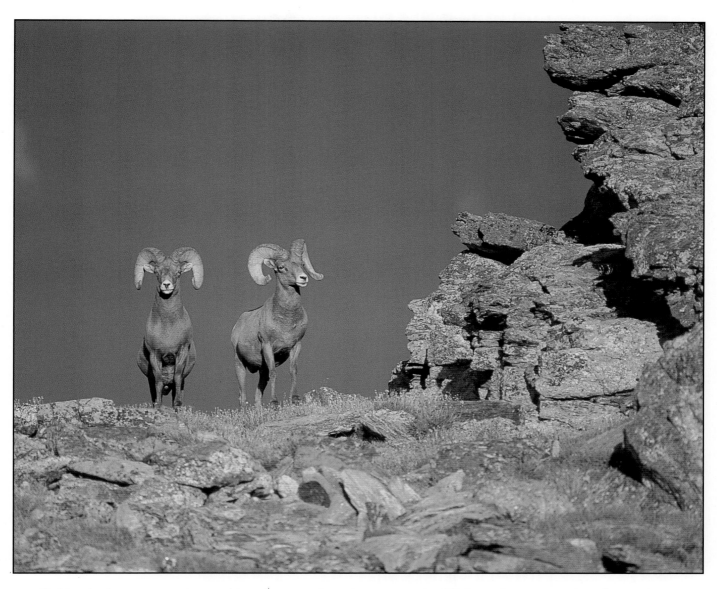

Basking in the warm evening sunshine after a passing rainstorm, a pair of bighorn sheep rams enjoys the scenic view from the rugged crags above Rock Cut.

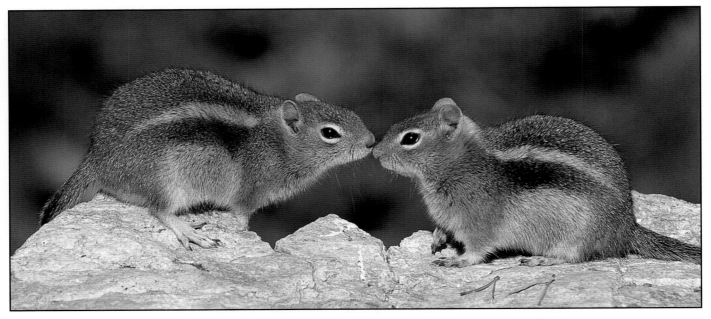

Golden-mantled ground squirrels have copper-colored fur on their shoulders.

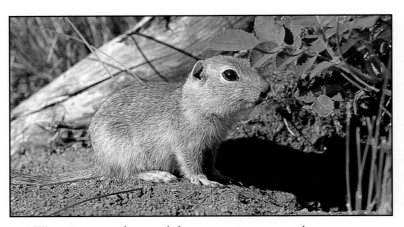

Wyoming ground squirrels have no stripes, even when young.

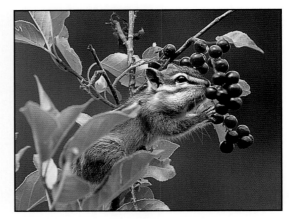

This least chipmunk is dining on chokecherries.

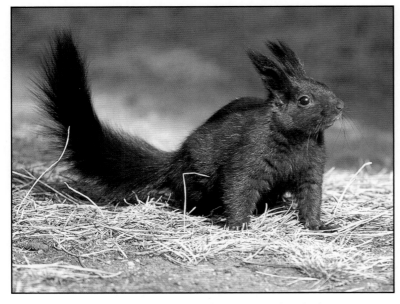

The Abert's squirrel can be black or gray, with tufted ears. It lives high in ponderosa pines and feeds on its cones.

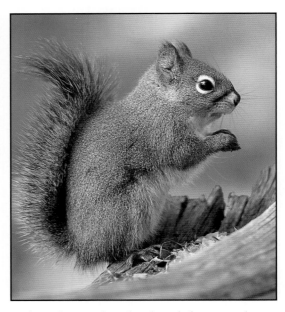

The red squirrel is often heard chattering from high in the conifers where it eats pine cones.

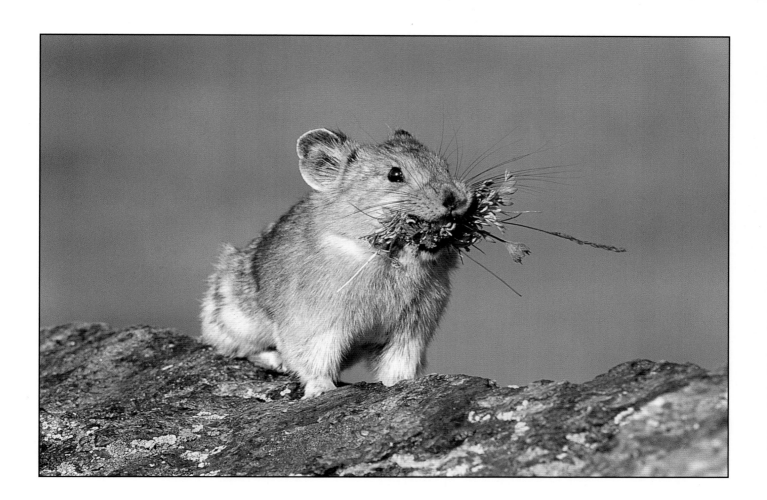

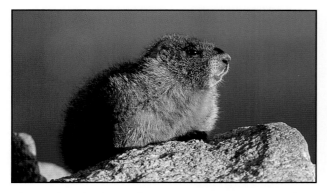

Tiny pikas (top) may be seen scampering among the jagged rocks on the alpine tundra. These industrious little animals spend the summer diligently collecting mouthfuls of plants and carrying them to crevices under the rocks. Pikas are members of the rabbit family and do not hibernate. Instead, they spend the winter among the rocks under the snow, eating their cache of stored food.

Yellow-bellied marmots live throughout the park and are usually lazily sunning themselves on rocks. They are nicknamed "whistle pigs" for the sounds they make when alarmed. Marmots gorge on plants and grass during the summer to accumulate body fat. Like most members of the squirrel family, marmots pass the winter hibernating in their underground burrows.

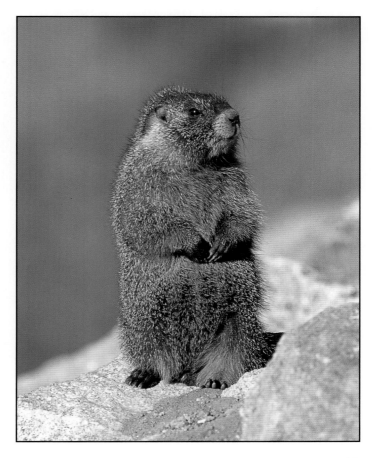

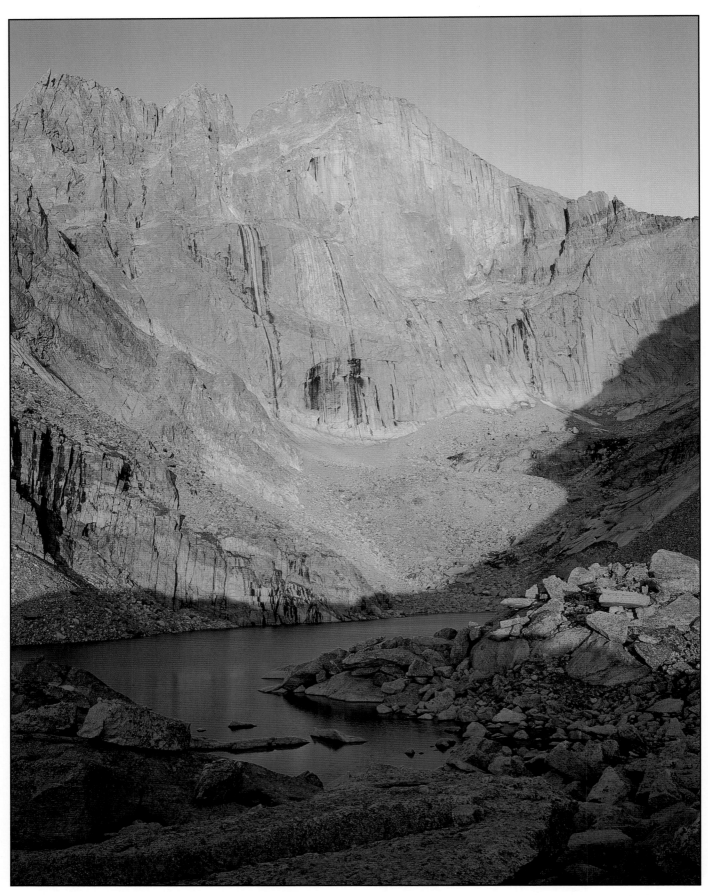

The imposing east face of Longs Peak, rising nearly a half mile above Chasm Lake, is an inspiring spectacle that epitomizes the rugged mountain grandeur of the park.

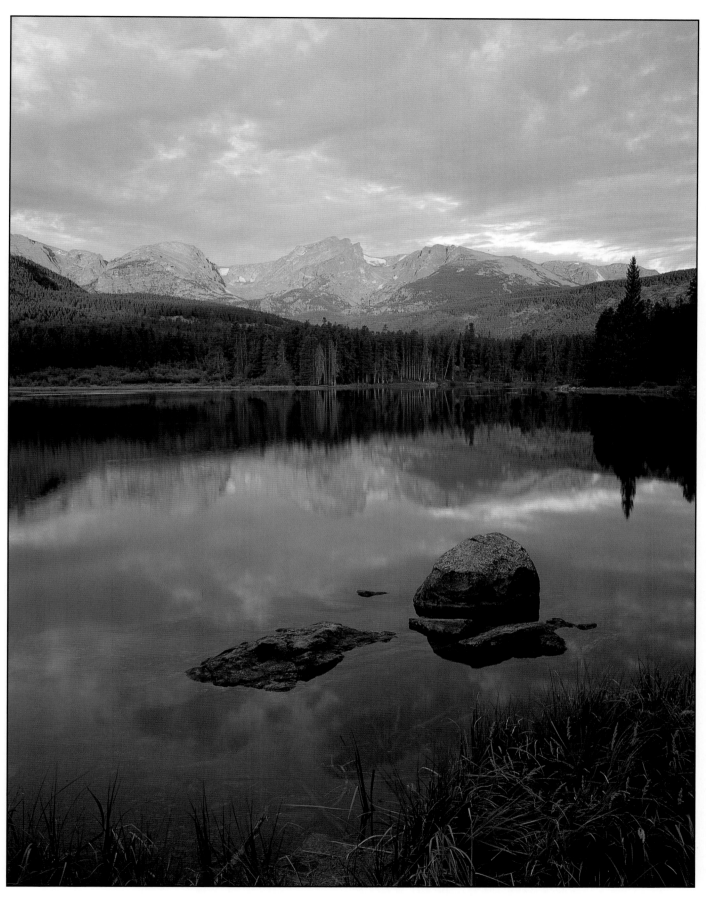

Sprague Lake reflects a summer sunrise on Mount Otis, Hallett Peak, and Flattop Mountain.

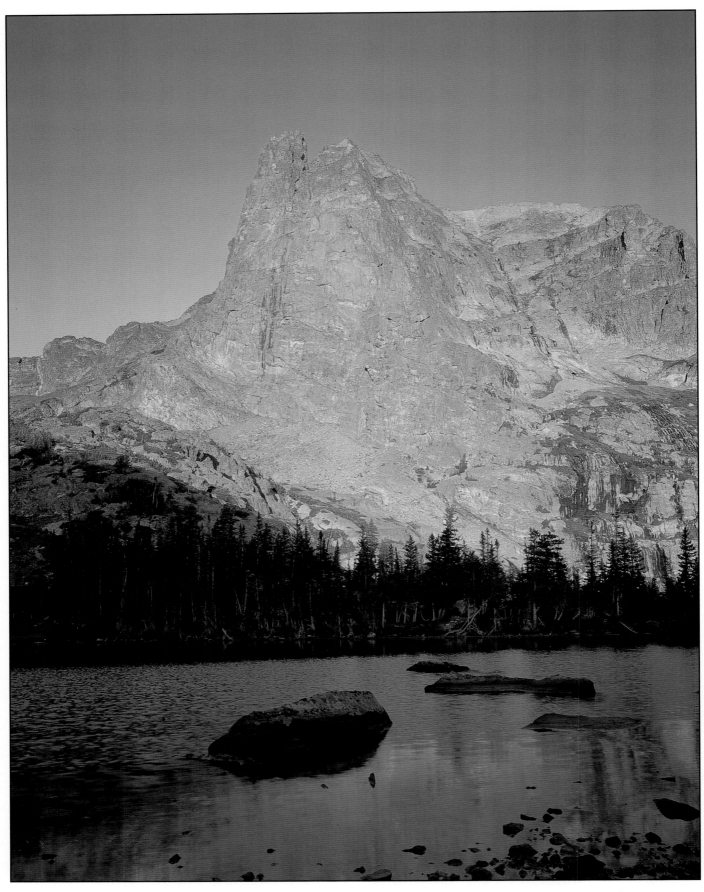

Named for its cleft summit, Notchtop Mountain dominates the view over Lake Helene at sunrise. Near timberline at 10,675 feet, the lake is surrounded by subalpine fir and dense willows.

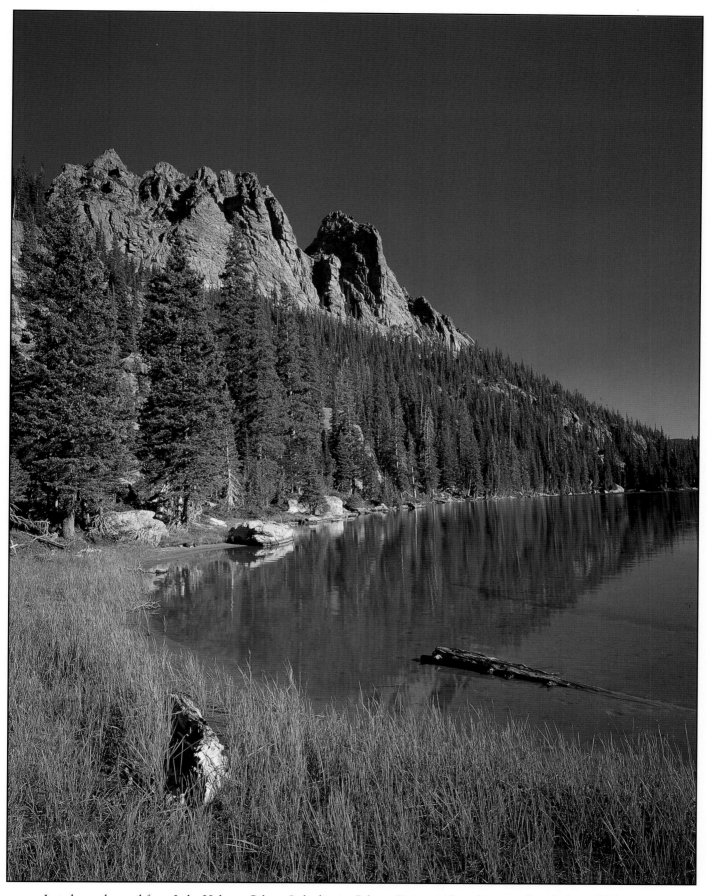

Just down the trail from Lake Helene, Odessa Lake lies in Odessa Gorge, midway between Bear Lake and Moraine Park. This rocky precipice called The Gable overlooks the lake from the northwest.

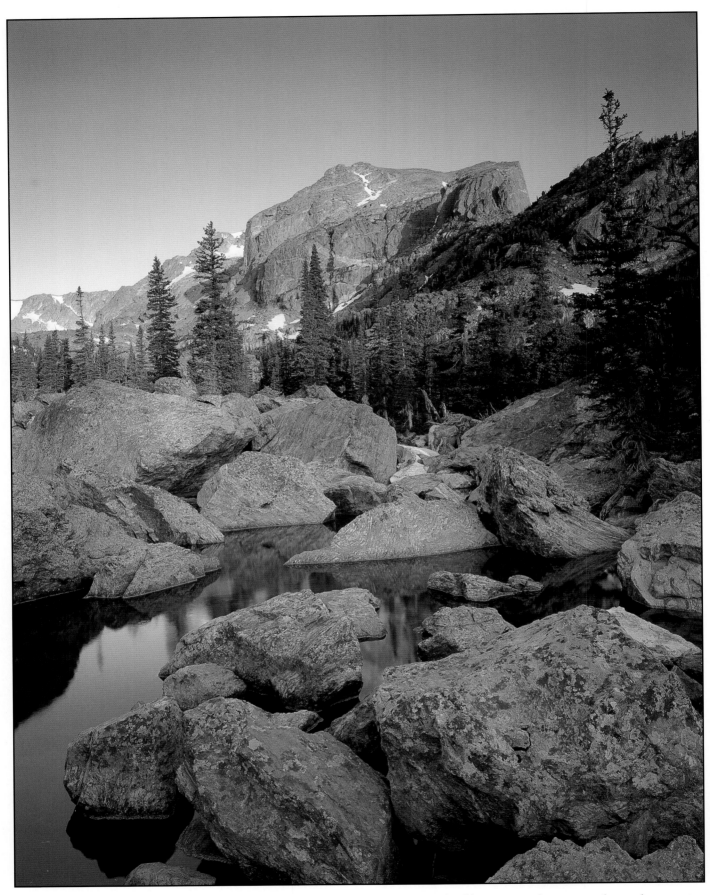

The last few yards of the trail to Lake Haiyaha pass among many huge boulders scattered on its southeast shore. "Haiyaha" is an Indian word meaning "rock." The familiar landmark of Hallett Peak has a different profile from this southeastern viewpoint.

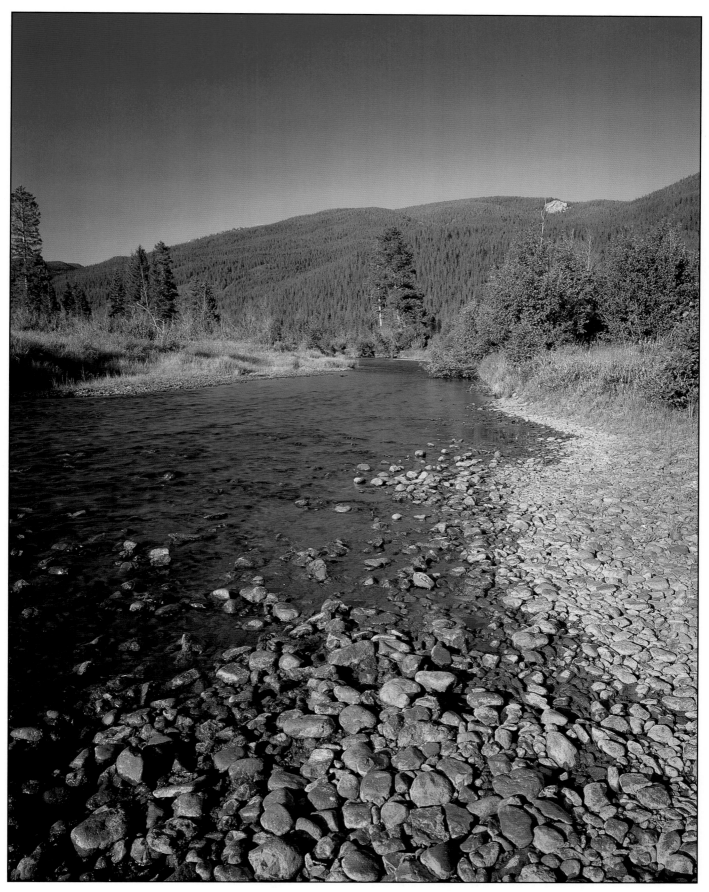

The mighty Colorado River has its humble beginning in the northwest corner of the park and meanders south through the Kawuneeche Valley. Little more than a trickle at this point, it will be joined by many other tributaries and pass through the Grand Canyon on its 1440 mile trip to the Gulf of California.

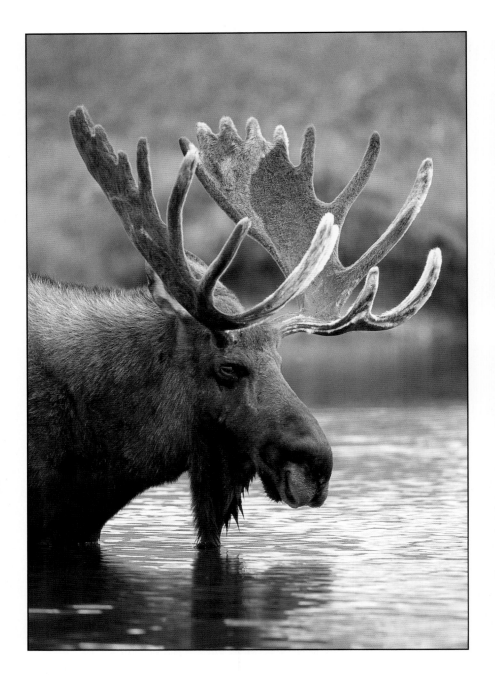

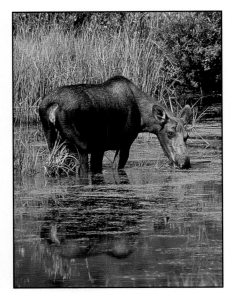

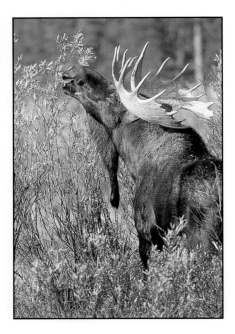

Moose are the largest member of the deer family, reaching seven feet tall and 1200 pounds. Moose live in riparian areas such as the Kawuneeche Valley, eating aquatic vegetation and willow branches. The bulls have huge palmate antlers that are shed each spring and regrown each summer, nourished by a fuzzy covering called velvet that dries and falls off in the fall. Calves are born in the spring and follow their mother for a year.

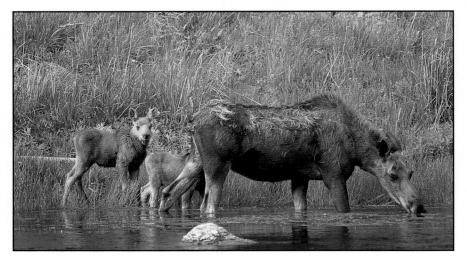

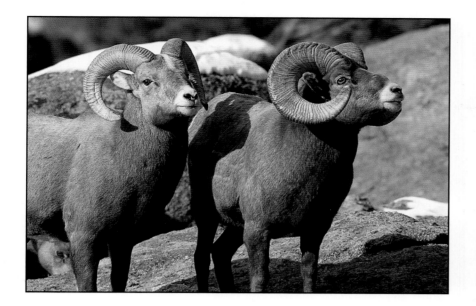

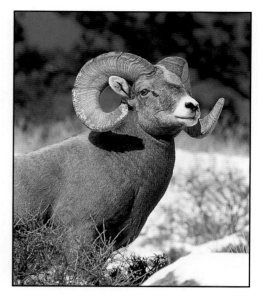

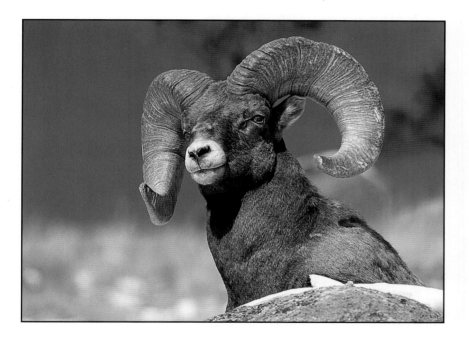

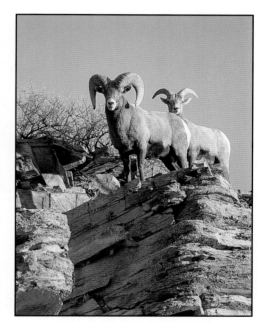

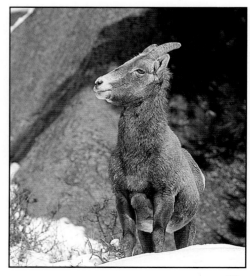

The stately Rocky Mountain bighorn sheep are famous for their large curled horns and dramatic head-butting battles. Bighorns stay in the high country during the summer, groups of males (rams) separate from the females (ewes). They may come down to Sheep Lakes in Horseshoe Park in the summer to lick salt and minerals. Ewes have short thin horns (right) but only the rams develop the heavy curling horns. A ram's horns continue to grow each year, reaching a full curl in about eight years. The sheep move to lower elevations for the mating season in November, when the most dominant rams compete for the receptive ewes. Bighorn social status depends on horn size and a complex system of body language that is usually sufficient to determine hierarchy. However, when that fails, the rams resort to their head-butting contests. The bighorn sheep is the official symbol of the park and the state animal of Colorado.

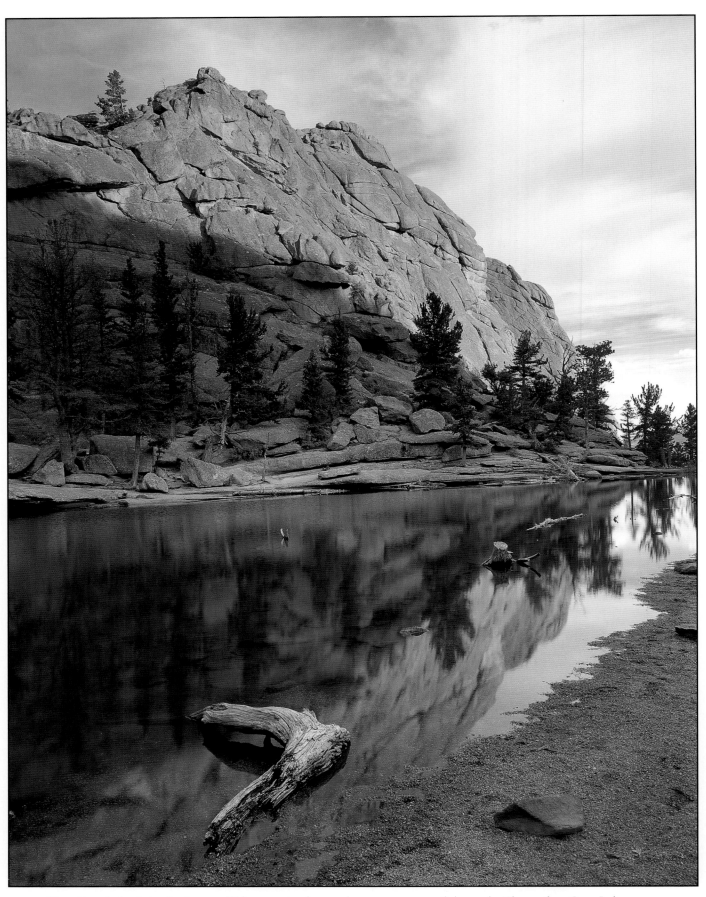

Tiny Gem Lake is in the Lumpy Ridge area in the northeastern corner of the park. The trail to Gem Lake passes through aspen groves and winds around the whimsical rounded rock formations that give Lumpy Ridge its name.

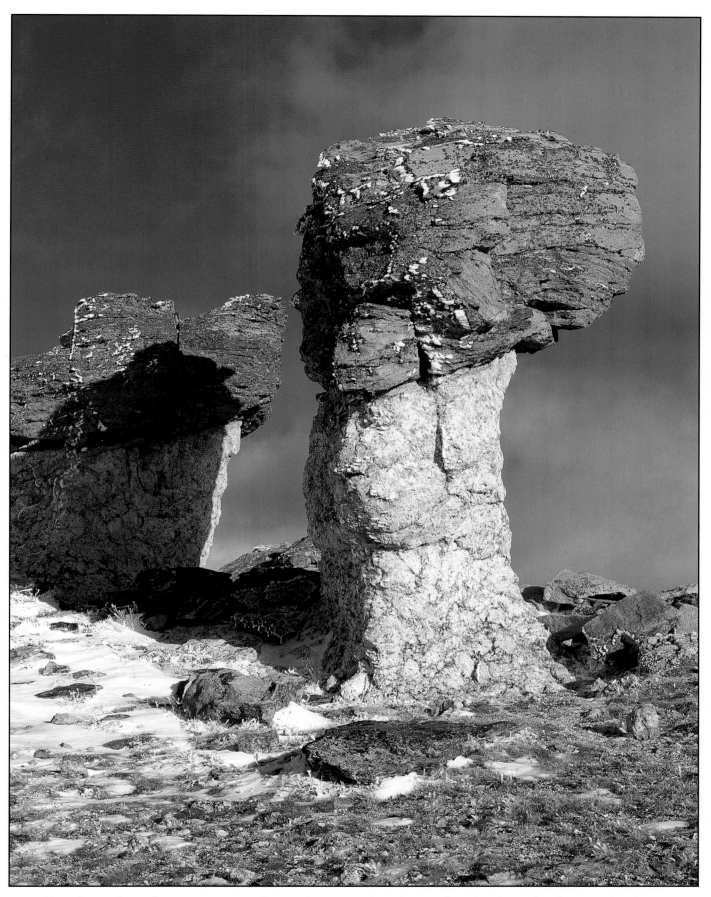

Bits of snow from a late summer storm cling to these unusual mushroom-shaped rocks on the alpine tundra above Rock Cut. The dark cap is a hard metamorphic rock called schist, which slowed erosion of the softer light-colored granite stem.

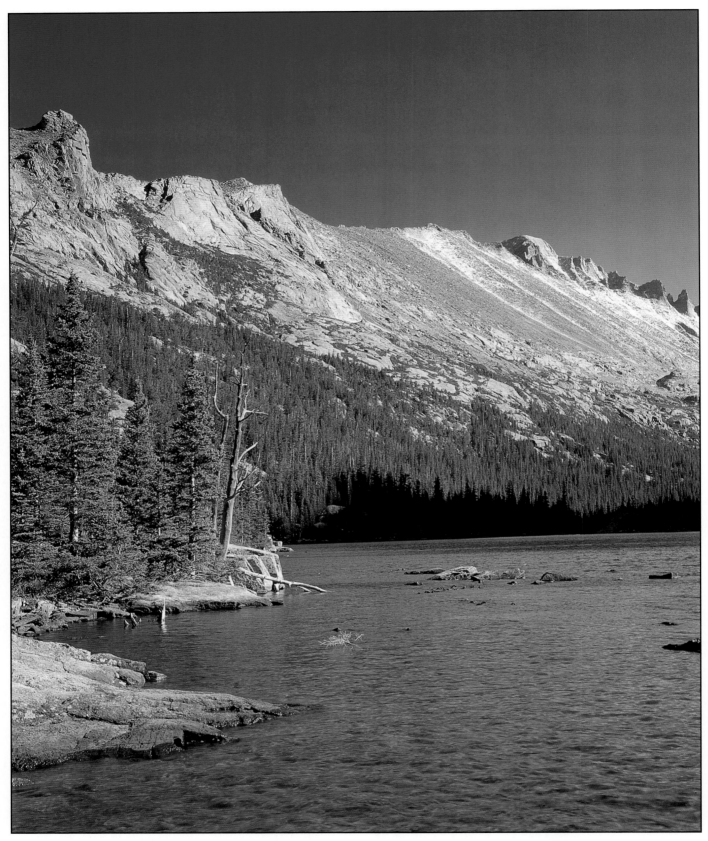

Mills Lake lies high in Glacier Gorge, beneath a dramatic backdrop of Longs Peak and Keyboard of the Winds. Mills Lake is named in honor of Enos Mills, who is regarded as the father of Rocky Mountain National Park. He came to the area in 1884 when he was only 14 years old and built a small cabin east of Longs Peak that still stands. Mills was a naturalist, author, innkeeper, and led many guided hikes to Longs Peak. His most important work was his seven-year campaign for the protection and preservation of these mountains. Those efforts were rewarded on January 26, 1915, when President Woodrow Wilson signed the legislation that created our tenth national park.

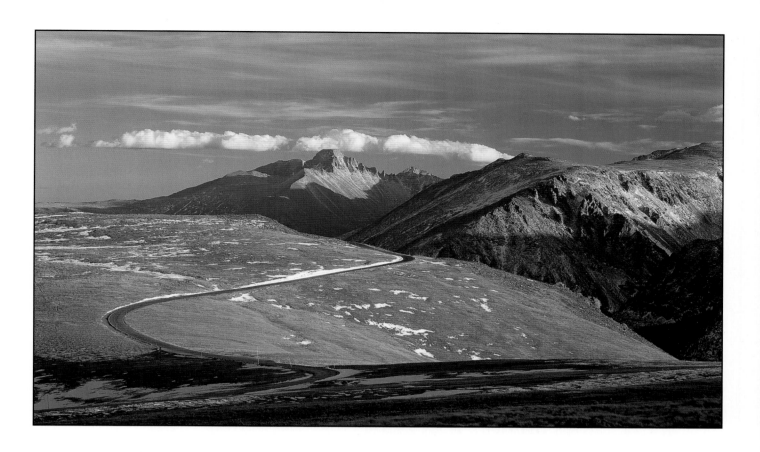

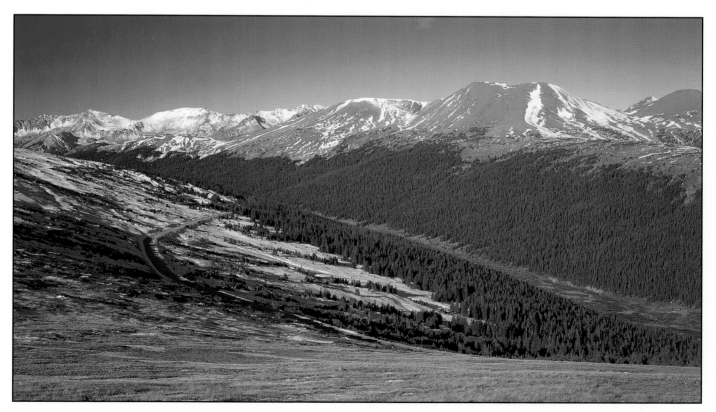

Trail Ridge Road is the highest continuous paved highway in the country and a major attraction of the park. Beginning near Estes Park, it climbs gently but steadily, crossing treeline just above Rainbow Curve. The road continues across the open alpine tundra for about eight miles (top) amid spectacular scenic views of rugged mountains. The road passes its highest point at 12,183 feet before reaching the Alpine Visitor Center, then descends on its way to Milner Pass (bottom), and continues through the Kawuneeche Valley to Grand Lake. The road was constructed in 1929-1932 as an alternative to the narrow and winding Fall River Road.

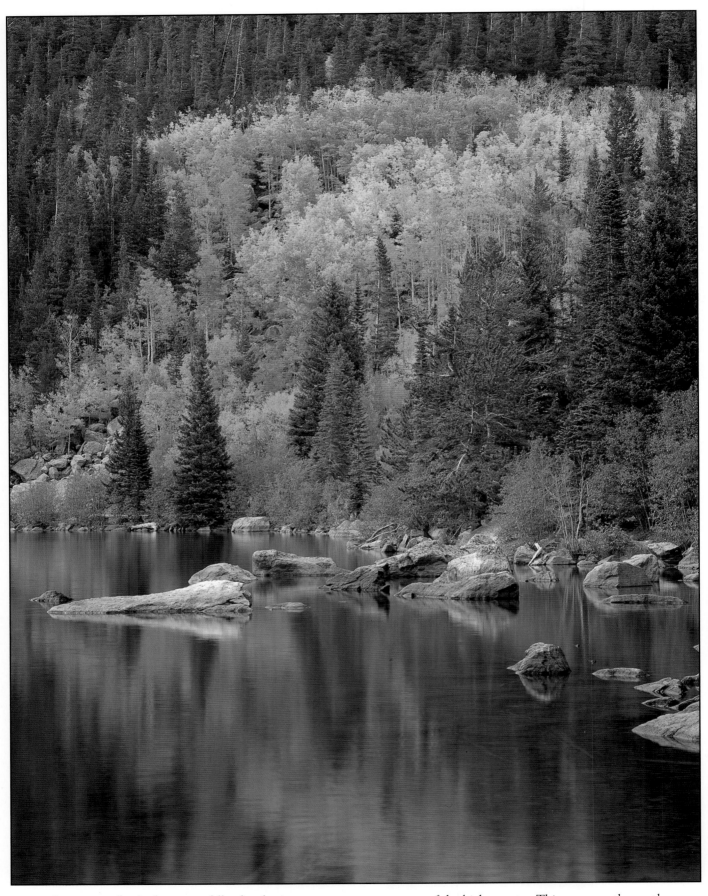

As summer slowly slips away, fall colors begin to appear on aspen trees of the high country. This grove on the north shore of Bear Lake is among the first to change each year. Over the next several weeks, waves of color will slowly sweep down the mountainsides.

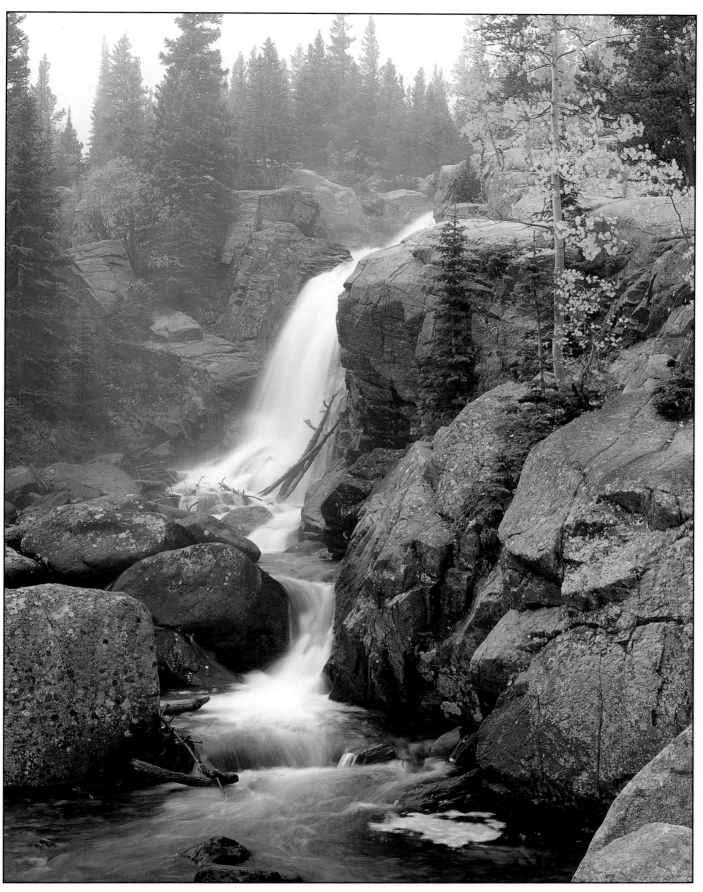

Fog shrouds Alberta Falls, a short and easy hike from Glacier Gorge trailhead. Abner Sprague named these falls for his wife, Alberta.

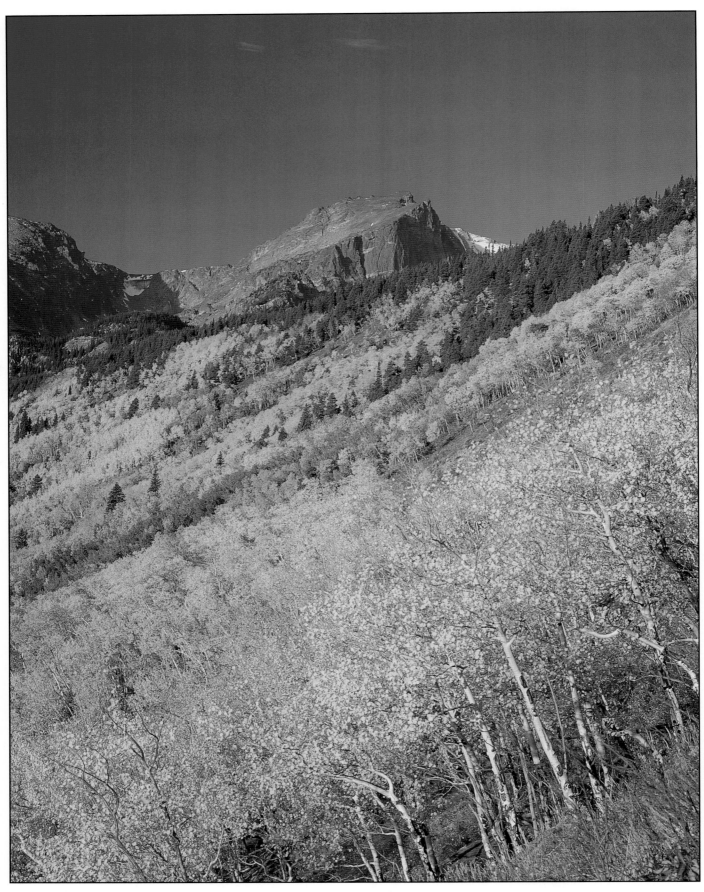

September brings a visual treat when autumn paints the hillsides with yellows and golds. The trail to Bierstadt Lake climbs up a glacial moraine along the Bear Lake road, through these spectacular groves of brilliant yellow aspen.

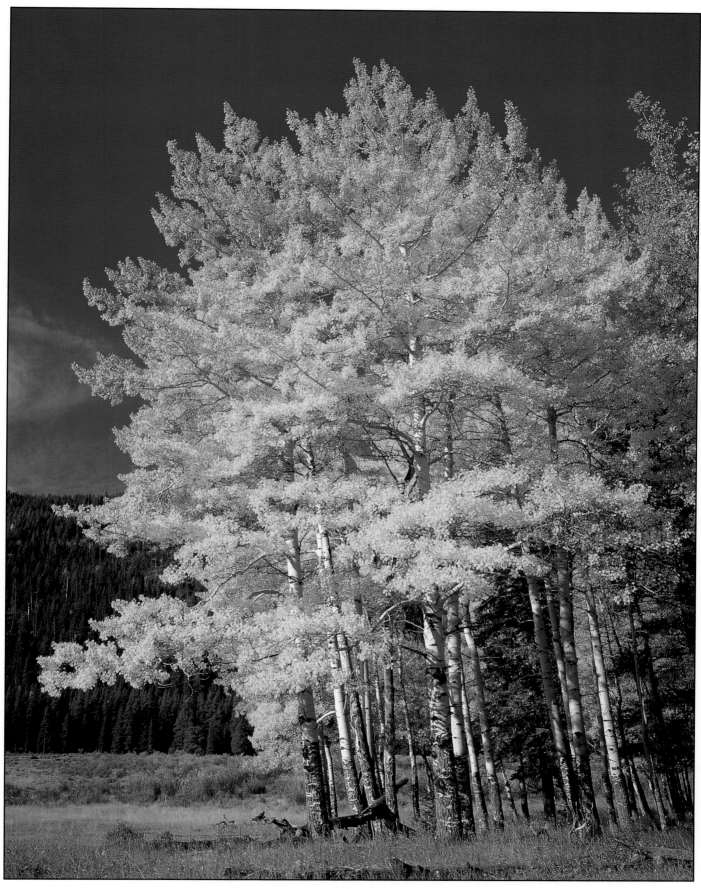

Autumn is a lovely time of the year, with cool days, deep blue skies, and sparkling yellow aspens. They are called "quaking aspen" because their leaves flutter in the slightest breeze.

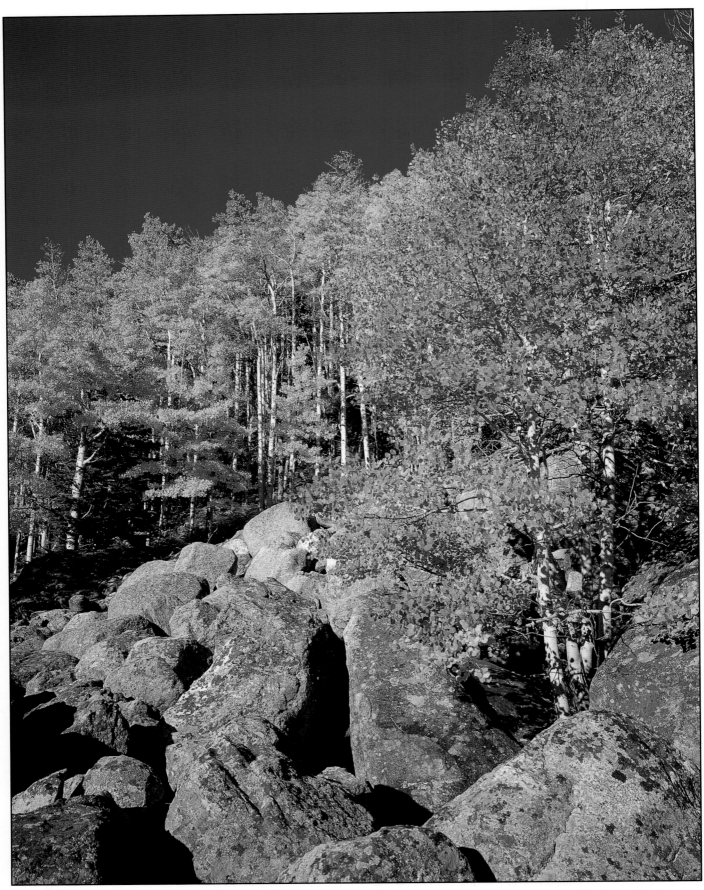

Aspens propagate through underground roots rather than seeds, so each group of trees is genetically identical and will change color simultaneously in the fall. However, nearby unrelated groups may change to different colors at different times. Aspen leaves usually turn yellow but shades of red and orange are also possible.

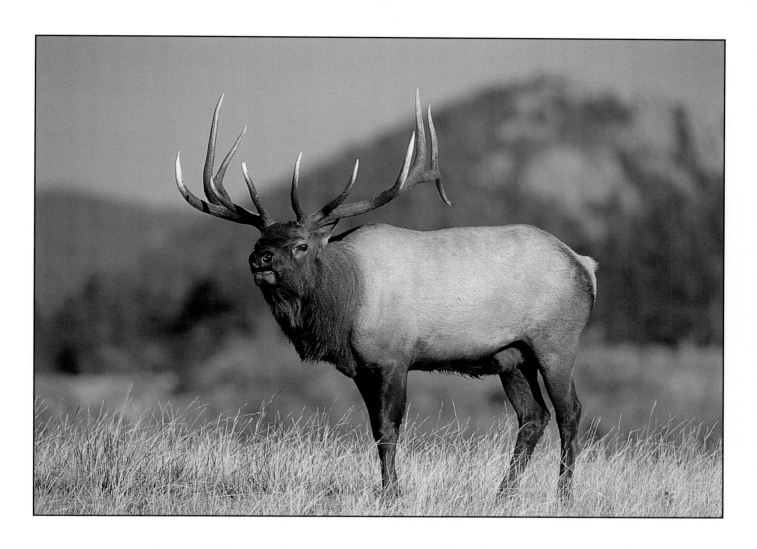

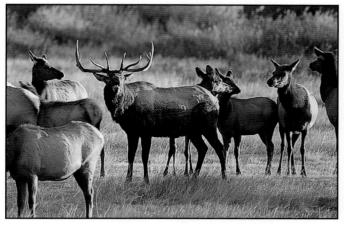

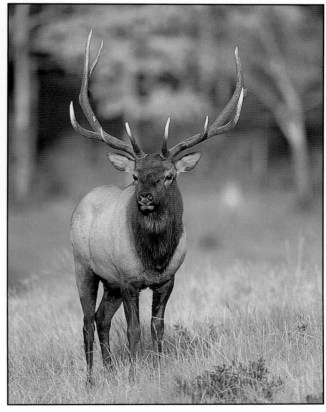

Shrill bugling sounds echo through the meadows in early September when the elk begin their mating season. The strongest bulls with the largest antlers (top) gather harems of cows (above) and defend them from persistent smaller bulls (right). They strut around to show off their imposing antlers, and bugle to attract cows and repel smaller bulls. Usually the larger bull can rebuff a smaller challenger with merely a threatening bluff, although occasionally two bulls will lock antlers and hold a vigorous shoving match.

57

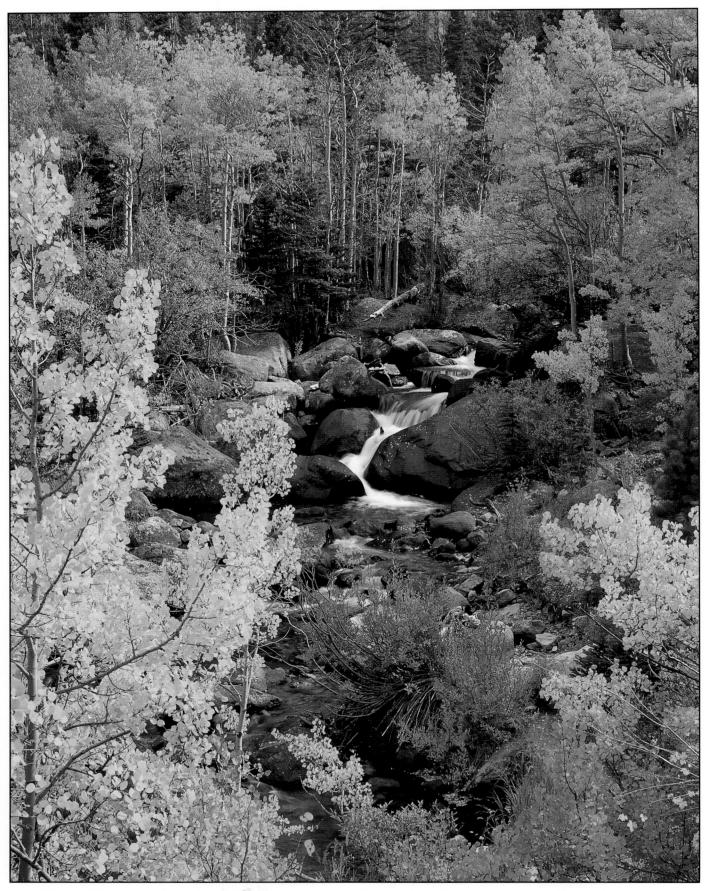

In the fall, streams and creeks that had been rushing with water throughout the summer have now dwindled to mere trickles.

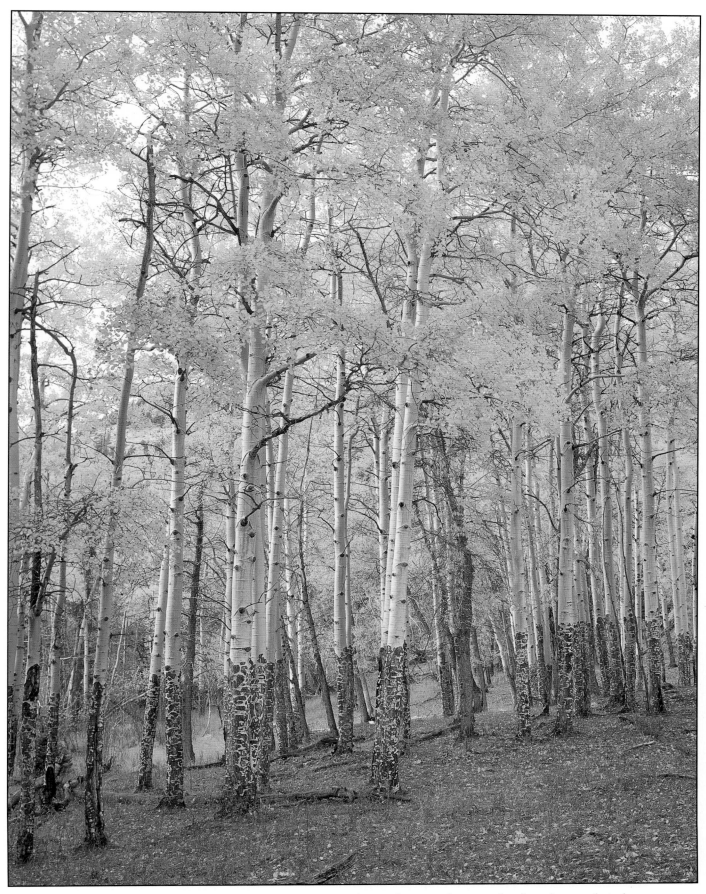

The annual pageant of fall color fades as more aspen leaves flutter to the ground with each gust of wind.

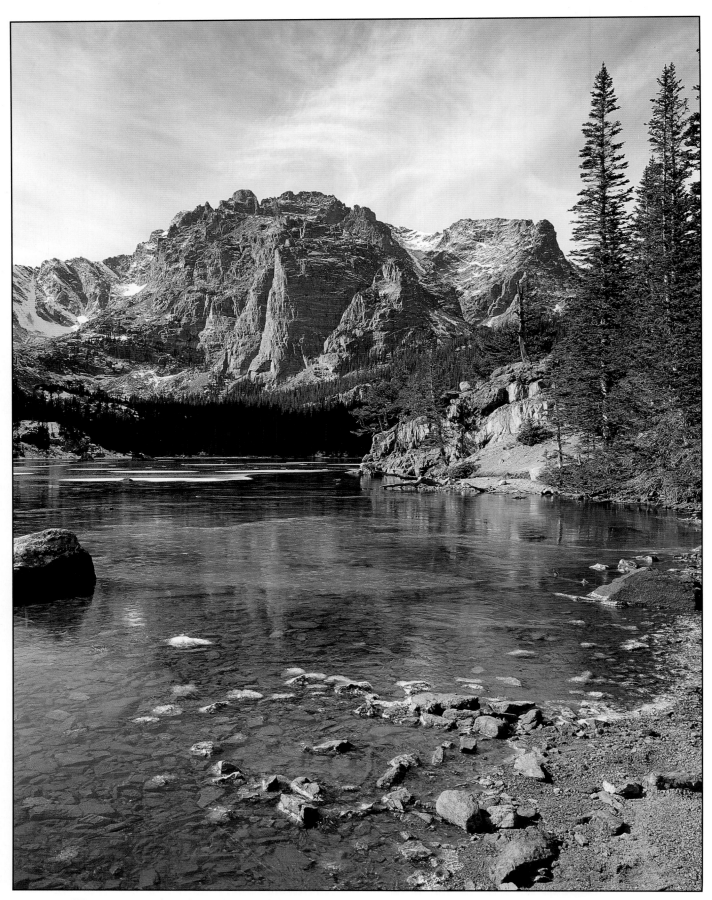

Winter is near when the surface of The Loch begins to freeze and snow starts to accumulate on Taylor Peak.

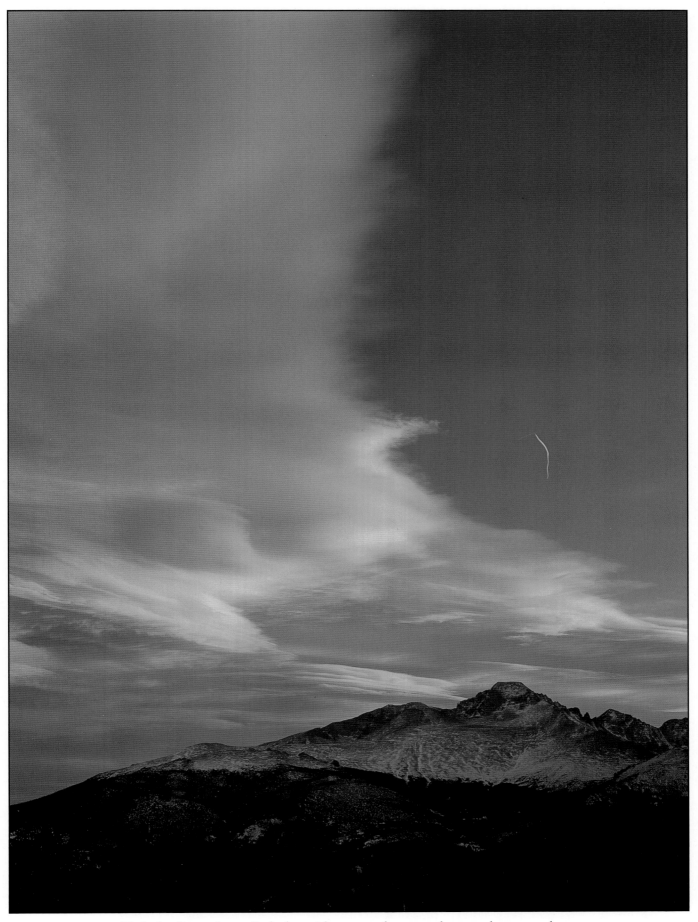

High clouds over Longs Peak glow with sunset color as another year draws to a close.

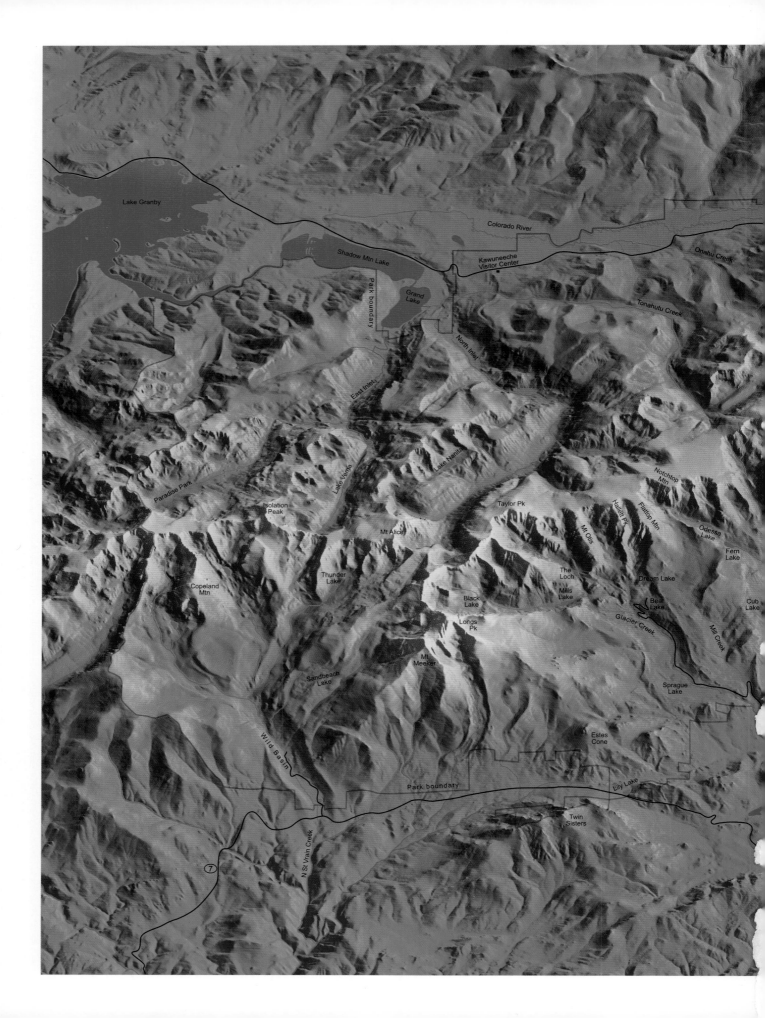

Lake Granby

Colorado River

Onahu Creek

Shadow Mtn Lake

Kawuneeche
Visitor Center

Tonahutu Creek

Park boundary

Grand
Lake

North Inlet

East Inlet

Notchtop
Mtn

Lake Verna

Lake Nanita

Paradise Park

Taylor Pk

Halleit Pk

Flattop Mtn

Odessa
Lake

Isolation
Peak

Mt Otis

Fern
Lake

Mt Alice

The
Loch

Dream Lake

Thunder
Lake

Mills
Lake

Cub
Lake

Copeland
Mtn

Black
Lake

Bear
Lake

Glacier Creek

Mill Creek

Longs
Pk

Mt
Meeker

Sandbeach
Lake

Sprague
Lake

Wild Basin

Estes
Cone

Park boundary

Lily Lake

7

N St Vrain Creek

Twin
Sisters

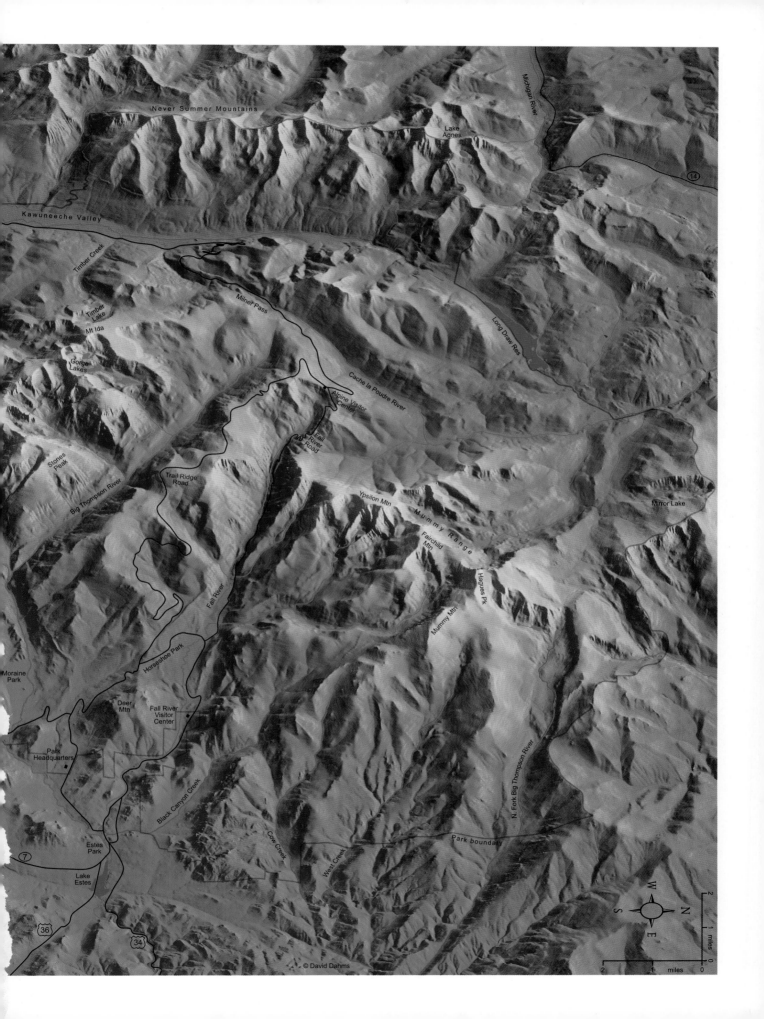

Never Summer Mountains

Michigan River

Lake Agnes

14

Kawuneeche Valley

Timber Creek

Milner Pass

Long Draw Res

Timber Lake

Mt Ida

Cache la Poudre River

Gorge Lakes

Alpine Visitor Center

Fall River Road

Stones Peak

Ypsilon Mtn

Mirror Lake

Mummy Range

Trail Ridge Road

Big Thompson River

Fairchild Mtn

Hagues Pk

Mummy Mtn

Fall River

Horseshoe Park

Moraine Park

Deer Mtn

Fall River Visitor Center

N. Fork Big Thompson River

Park Headquarters

Black Canyon Creek

Cow Creek

Park boundary

Estes Park

7

West Creek

Lake Estes

© David Dahms

36

34

W

N

S

E

2

1 miles

0

2 1 miles 0

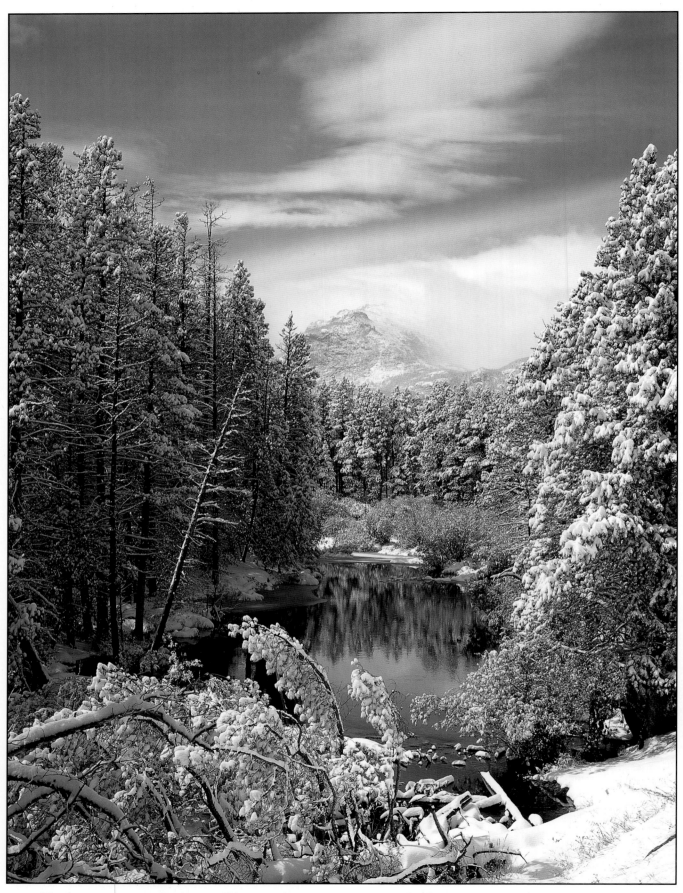

The first snowstorm of autumn still lingers, obscuring Mount Otis after leaving a frosting of fresh snow on the trees. Early autumn snows don't last long, but are a harbinger of things to come.